IMAGES
of America

WOODLAND

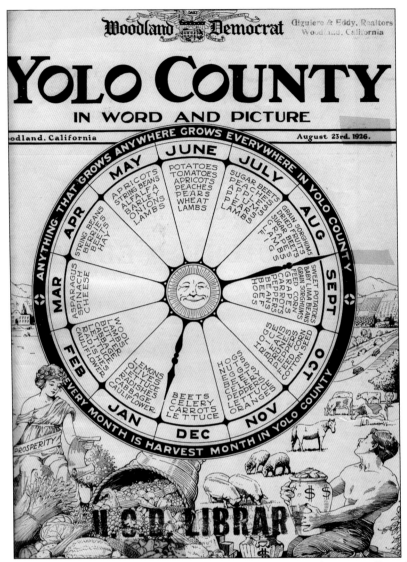

The *Woodland Daily Democrat* produced special publications in 1920 and 1926 extolling the virtues and opportunities of Yolo County. Almost everything on the cover of *Yolo County in Word and Picture* is agricultural, with only a small town scene appearing on the left. Most striking are the mottos that circle the agricultural calendar: "Anything that grows anywhere grows everywhere in Yolo County" and "Every month is harvest month in Yolo County." The second one is actually true. (Jim Smith, *Woodland Daily Democrat*.)

On the Cover: The railroads brought visiting dignitaries, including presidents and presidential candidates, to Woodland. Without the rail connections, many of these visitors would not have come. Here, a Sacramento Northern train on Main Street has attracted a crowd, including a band. The visitor may have been famous politician, social critic, and orator William Jennings Bryan, who came to Woodland several times, including in 1918 as a Chautauqua speaker. (Yolo County Archives.)

IMAGES
of America

WOODLAND

Robin Datel, Dennis Dingemans, and
Thomas Krabacher

ARCADIA
PUBLISHING

Published by Arcadia Publishing
Charleston, South Carolina

Printed in the United States of America

Library of Congress Control Number: 2011931598

For all general information, please contact Arcadia Publishing:
Telephone 843-853-2070
Fax 843-853-0044
E-mail sales@arcadiapublishing.com
For customer service and orders:
Toll-Free 1-888-313-2665

Visit us on the Internet at www.arcadiapublishing.com

*This volume is dedicated to the Yolo County Historical Society
for getting things done on behalf of the past and to its longtime
president, BJ Ford, for her ever-positive outlook on the future.*

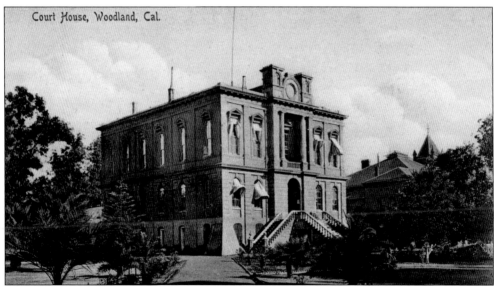

Yolo County voters decided to move their seat of government to Woodland in 1862 after the Sacramento River flooded Washington. Within two years, this noble Italian Renaissance Revival courthouse had been built on the city block bounded by Court, North, Second, and Third Streets and on land donated by town founder Franklin Freeman. Designed by Albert A. Bennett, architect of the California State Capitol, the impressive structure added urbanity to Woodland's rustic streets. (Yolo County Archives.)

CONTENTS

ACKNOWLEDGMENTS

We wholeheartedly thank Moira Conlan and Amanda Mason of the Yolo County Archives and David Flory and Stella Dinger of the Yolo County Historical Museum (Gibson House) for their generosity in giving us access to and help with their collections. We deeply appreciate those public officials, businesses, organizations, and individuals who support these institutions. We are indebted to the authors of previous works on Woodland and Yolo County, particularly the following: Shipley Walters, *Woodland, City of Trees: A History*, 1995; David L. Wilkinson, *Crafting A Valley Jewel: Architects and Builders of Woodland*, 2003; Ron Pinegar and David Wilkinson et al., *Explore Historic Woodland, A Walking Tour Guide*, 2007; and Joann L. Larkey and Shipley Walters, *Yolo County: Land of Changing Patterns*, 1987.

We are very grateful to the following individuals and organizations who shared images and information with us (the parenthetical abbreviations are used in most photograph captions to indicate sources): Jan and Bill Adams (JBA); Al Eby, Blue Wing Gallery (BWG); Susan Bovey (SB); Pat Johnson, archivist, Center for Sacramento History; Dennis J. Dingemans (DJD); Franklin P. Dingemans (FPD); Gibson House Museum (GHM); Girl Scouts, Heart of Central California Council (GSC); Heidrick Agricultural History Center (HAH); David Herbst (DH); Bill Hollingshead; Rachel Contreras Mallery; Nugget Market (NM); Lanny Ropke, Roy Hobbs Men's Senior Baseball League (RH); Marianne Ryan; Mike Adams, president, Sacramento Valley Historical Railways; Aaron Schmoekel; Marina Graham, Skyline Homes (SH); Tom Stallard; Stella Tafoya (ST); Helena Tafoya Ochoa (HTO); Bancroft Library, University of California, Berkeley; Dawn Collings, Map Collection, Shields Library, University of California, Davis (UCD); John Skarstad, Eastman Collection, Special Collections, Shields Library, University of California, Davis (UCDSC); Bruce and Steve Watts, Watts Woodland Field; James Lingberg, Woodland Boy Scouts (WBS); Woodland Chamber of Commerce; Jim Smith, *Woodland Daily Democrat* (WDD); Woodland Elks Lodge (WEL); Woodland YMCA (WYMCA); Yolo County Archives (YCA); BJ Ford, president, Yolo County Historical Society (YCHS); and Lisa Baker, executive director, Yolo County Housing. The participation of these individuals and groups helped make this book a community endeavor.

INTRODUCTION

Country and city have intertwined to create the character of Woodland, California. The flat, rich land of the Great Central Valley, along with its Mediterranean climate and access to irrigation water, enabled Yolo County to become a top producer of diverse agricultural products. The wealth of the countryside flowed into Woodland, the county's seat of government, largest market town, and major agricultural processing center. In 1888, Woodland was described, albeit by a regional booster publication, as the wealthiest town of its size in the country. Rural wealth underpinned Woodland's distinguished architecture, abundant cultural and leisure activities, and prosperous businesses.

Woodland is close to two larger urban areas: Sacramento, the state's political capital, and San Francisco, the cultural and economic capital of the northern part of the state. These places provided Woodlanders with opportunities to influence and be influenced in ways that more distant towns lacked. The city's history also reflects national and global events, including technological and organizational innovations, war and social movements, and changing patterns of immigration. Woodland has been a progressive place, cultivating ideals of democratization, education, and social service.

Woodland gained the critical county seat function in 1862 when, in a county-wide election, Franklin Freeman's not-yet-platted townsite was chosen over a recently underwater rival. Woodland benefited in the very wet winter of 1861–1862 from not being on the Sacramento River and from being a full four miles from Cache Creek. Capturing the county seat paid dividends right away, attracting many functions tied to local government such as law, banking, education, engineering, and journalism. By the mid–20th century, being a county seat meant big growth, and Woodland grew. Despite nine-fold absolute growth since 1940, it fell 10 places down the urban hierarchy of the 18 Central Valley counties mostly due to the growth of Sacramento and Bay Area suburbs.

Yolo County agriculture took off shortly after the Gold Rush and has undergone many changes since. It turned to, in sequence, cattle and sheep grazing, grain production, fruit and nut horticulture, and dairying, eventually becoming highly diversified. Rice, sugar beets, canning tomatoes, seeds, wine grapes, and organic crops have made their mark. Woodland firms provided Yolo County ranchers and farmers with everything from agricultural implements and banking to weighing and well-drilling. Local agriculturalists were innovators and strivers; they improved their herds, tried new crops, aggressively expanded irrigation, invented new equipment, and recruited labor from far away. They entered their products in local, state, national, and international exhibitions and won prizes.

Transportation linkages were required for all this: the California Pacific Railroad (later the Southern Pacific) arrived in 1869 and the Sacramento Northern, part of a vast electric interurban system, in 1912. Bicycles were popular in Woodland, and their riders advocated for good roads around the county. Californians were early automobile adopters, and Woodlanders were no exception. Eventually, Interstate 5 came to town, strengthening Woodland's role as a distribution

center. Small airfields appeared and were used by recreational fliers and for the serious business of seeding and spraying.

Woodland has been buffeted by wars and affected by social movements. Because prices to farmers go up during wartime, Woodland's agriculturally based economy did well during the world wars, and its citizens were able to buy more than their fair share of war bonds. The need for imported agricultural labor during World War II brought the Bracero Program, and eventually, a major migration stream from Mexico significantly altered the ethnic mix of Woodland. The Women's Christian Temperance Union left one temporary mark on the city by successfully campaigning to close all its saloons and one permanent mark by successfully campaigning for women's suffrage in California—won in 1911.

Main Street has been and remains the spine of Woodland, albeit today stretched by the automobile well beyond its six-block core from Walnut Street to Fourth Street. Small-town "Main Street" is among the most potent symbolic landscapes of America, signaling important national ideals, such as entrepreneurship, optimism, and community. While individuals, enterprises, and some buildings have come and gone, the old downtown has retained its overall 19th-century morphology. The nature of the businesses in the core has changed, as many sellers of everyday goods and services have shifted outward to bigger buildings surrounded by parking lots. Purveyors of food and drink, specialty goods, and high-order services now use Main Street's historic ambiance and pedestrian scale to attract customers. Community celebrations still seek out this time-honored space, although parades are much less common than in the past.

The last economic census indicated that even now the majority of Woodland's jobs in manufacturing are in food processing and wood products, as they were in the past. This sector has seen a major locational shift toward larger, truck-friendly quarters near Interstate 5. Many old industrial buildings have been demolished, although Woodland has a few, such as the Globe Rice Mills, that have been adaptively reused. From storing grain, the city's warehousing and distribution function has expanded to serve large chain enterprises, such as Target and RadioShack. Modern factories and warehouses create a horizontal city, in contrast to the old grain silos and utilities that gave Woodland a skyline.

Woodlanders are justly proud of their homes. The prosperous classes, rural and urban, are well represented by a collection of fine properties. The Gable House, an 1885 Italianate mansion, would be a landmark even if it were in San Francisco. Many modest homes from the city's first 100 years also survive to delight the eye. After World War II, Yolo County Housing became an innovator in meeting the housing needs of low-income Woodlanders.

Throughout its first 100 years, Woodland residents built attractive churches, educational institutions, fraternal lodges, public facilities, medical complexes, and other vessels of communal life. Many that appear in these pages have disappeared, having become in some instances structurally compromised and functionally obsolete and difficult to adapt in others. Despite these landscape losses, many of the organizations established decades ago continue to serve Woodland. In other cases, their ideals and missions are carried forward by new groups.

All work and no play would make Woodland a dull place. Avoiding that fate, the town embraced the outdoor life that is so much apart of the appeal of California, via horseracing, bicycling, hunting, picnicking, driving, camping, and scouting. The Woodland Opera House, now a state historic park, was the key venue for music, theater, lectures, and much more; later, movie houses abounded. Woodland has long embraced team sports and remains especially fond of baseball. Numerous recreational activities are highlighted at the still free-admission county fair, one of California's last.

Today, Woodland's 56,000 residents and its many visitors can enjoy the city's history due to the hard work and success of authors and preservationists. We hope that the images in this book will inspire readers to contribute their own energies to caring for the past.

One

CONNECTIONS
RURAL AND URBAN

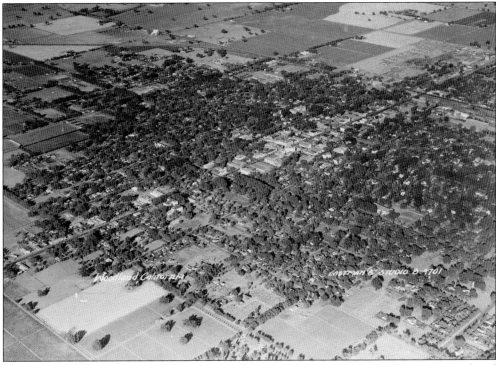

Cultivated fields around Woodland in this 1946 aerial photograph indicate the city's agricultural setting. Woodland's function as a central place, providing goods and services to a rural hinterland, is suggested by its well-developed Main Street (running from lower left to upper right). Its county government role is embodied in the courthouse, the large building just above (north of) Main Street. The railroad, symbolizing more distant points of connection, crosses Main Street at right angles and curves across the upper portion of this photograph. (UCDSC.)

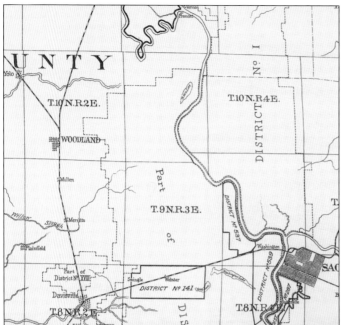

This 1895 Swamp Land Districts map (at 1:190,000) was created in conjunction with state legislation encouraging reclamation. It shows Woodland's proximity and connection to Davis via rail. The proximity of Sacramento is also evident. Note Woodland's distance from the Sacramento River and Cache Creek north of town. This relatively well-drained location proved a boon in the days before effective flood control. (UCD.)

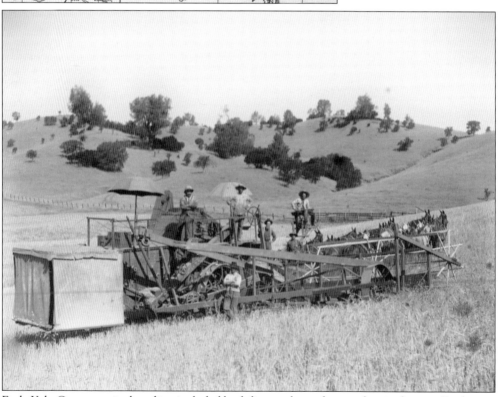

Early Yolo County agriculturalists included both livestock ranchers and grain farmers. Both were successful, and many brought their products to market through Woodland. Here, in the hilly country west of town, mules draw a harvester through a wheat field. Many Central Valley farmers were early adopters of mechanization, due to local labor shortages. (YCA.)

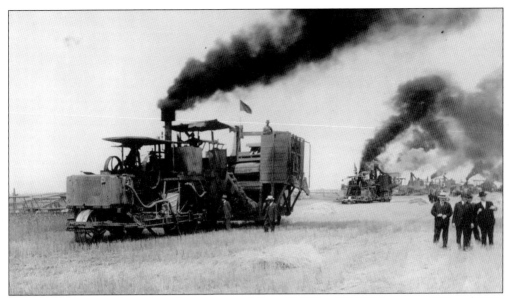

Yolo County's acres planted in wheat increased from 13,000 to 231,000 between 1860 and 1893. Barley, too, was a significant crop. Successful grain farmers and grain dealers made up a big share of Woodland's business elite. Their grain-based prosperity owed much to excellent natural conditions; money-saving agro-mechanical innovations, such as these steam-powered combines; and a growing global market for grain. (GHM.)

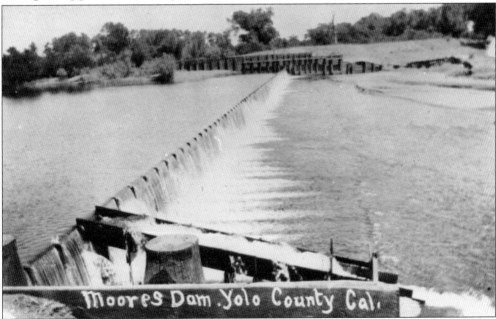

Farmer James Moore first built a brush and gravel dam across Cache Creek west of Woodland in 1856. Moore's ditch, which distributed that water, was initially only 3.5 miles long. By 1864, an improved dam and enlarged canal irrigated 15,000 acres of alfalfa and 300 acres of grapevines. Eventually, impounded water from the dam was applied to thousands of acres of farmland in central Yolo County. Irrigation resulted in higher yields per acre of wheat and alfalfa and in the spread of orchards. (YCA.)

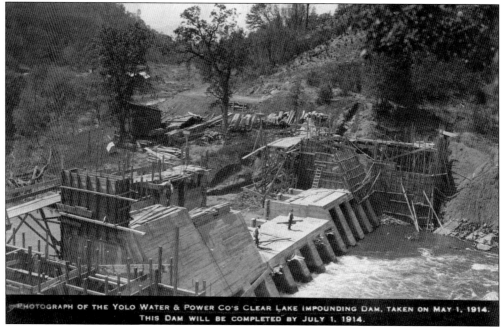

PHOTOGRAPH OF THE YOLO WATER & POWER CO'S CLEAR LAKE IMPOUNDING DAM, TAKEN ON MAY 1, 1914. THIS DAM WILL BE COMPLETED BY JULY 1, 1914.

As the demand for irrigation water grew, the Yolo Water and Power Company, organized in 1912 by Bay Area capitalists, built dams farther up Cache Creek. By 1916, the company was delivering water to 600 customers. The spread of irrigation in Yolo County was accompanied by increases in nut and rice acreage. (YCA.)

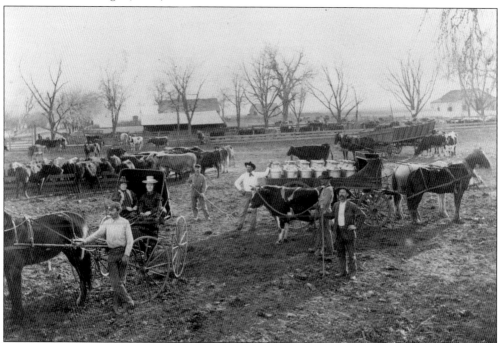

Yolo County dairying prospered as California's growing population demanded more milk products. Expanded irrigation enabled the production of multiple alfalfa crops per year, and farmers invested in improved herds by purchasing purebred animals from the Midwest. (YCA.)

Starting in 1908, Asa W. Morris bought purebred Holstein-Friesian dairy cows from the Midwest to improve the herd on the Tule Ranch east of Woodland. In 1910, he purchased two-year-old Tilly Alcartra, who alone among cows of her day produced more than 33,000 gallons of milk in a year (more than 90 gallons a day). One of her calves sold for $50,000 in 1920. (YCA.)

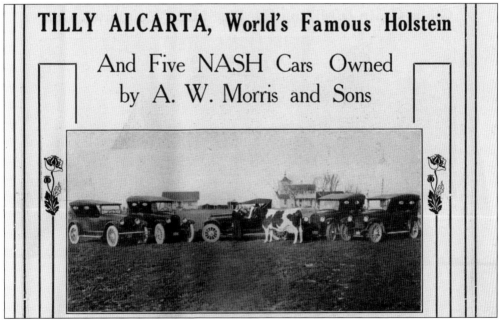

TILLY ALCARTA, World's Famous Holstein

And Five NASH Cars Owned by A. W. Morris and Sons

Tilly's celebrity status got her into the Palace Hotel in San Francisco and also led to her appearance in advertisements for various products. Ultimately, she met a sad end as part of the effort to control the 1924–1926 outbreak of hoof and mouth disease in California—but not before adding to the agricultural wealth and reputation of the Woodland area. (YCA.)

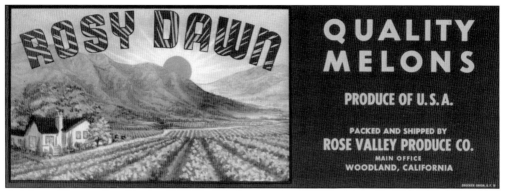

California's horticultural bounty, in this case melons, was celebrated on fruit crate labels. Melons, especially honeydews, continue to be a major crop in Yolo County, and the Rose Valley Produce Company (now the Rose Valley Group) of Woodland continues to produce them. (YCA.)

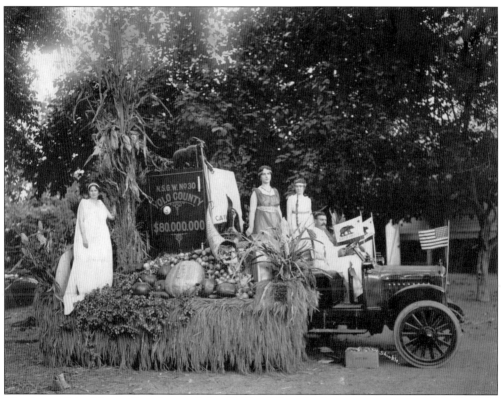

Members of the Native Daughters of the Golden West display a cornucopia of Yolo County agriculture. Their dress hearkens back to Roman times, suggesting California's similarity to that Mediterranean empire. Woodland parades often included agricultural equipment and floats with agricultural themes, especially the annual county fair parades. (YCA.)

Fifteen counties were represented in this Sacramento Valley exhibit at the 1919 California State Fair. Honey, asparagus, and preserved fruits were among the products displayed. As Yolo County grew more fruit and nut crops, its farmers became more dependent on bees. University of California, Davis, just a few miles away, has developed a major honeybee research center. (YCA.)

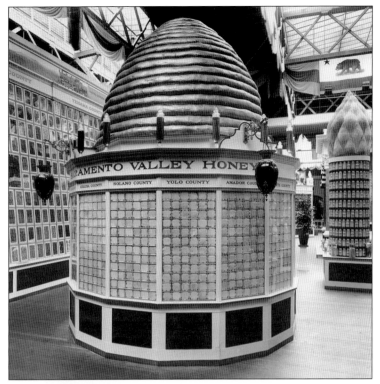

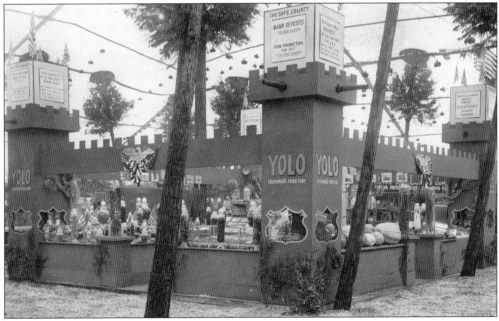

The designer of this Yolo County exhibit for the 1918 California State Fair chose the themes "Yolo: California's Food Fort" and "Yolo: The Safe County," clearly relating to American involvement in World War I. The food fort is filled with displays of Yolo County's agricultural bounty, signs announcing total and per capita bank deposits (most of which would have been in Woodland) and patriotic symbols. (YCA.)

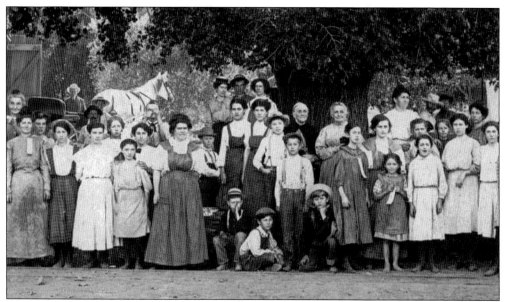

Another connection between Woodland and its agricultural hinterland was the town's supply of temporary workers to farms at peak harvest times. Women and children often filled these roles, and this was especially true when the country was at war. Here, a large group has assembled at Yolanda, the Jackson-Hecke-Hardy property just south of Woodland, to harvest apricots. (GHM.)

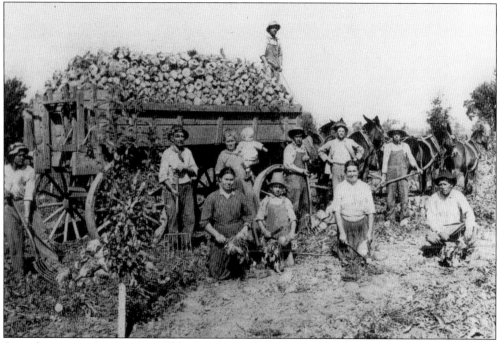

Sugar beets were first grown in Yolo County in the 1880s on the H. Coil farm. A crew displays the implements that were used to harvest sugar beets, an arduous task involving digging, topping, windrowing, and forking the beets into the wagon. Meeting the need for seasonal agricultural workers became a growing issue as sugar beets increased in importance around Woodland in the 1930s. (HAH.)

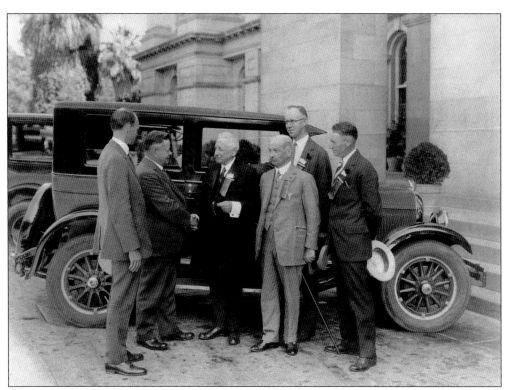

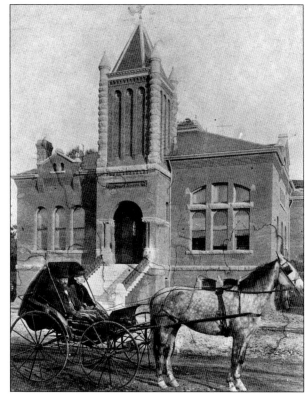

Some Woodland area farmers were well connected politically and attracted visits from national political figures. Here, George Henry Hecke (second from the left), the owner of the Yolanda farm, is shown with Henry Morganthau Jr. (far left). Morganthau was editor of the *American Agriculturalist* and was named governor of the Federal Farm Board and secretary of the treasury under Franklin Roosevelt. (GHM.)

The Torrences, pulled by Daisy, are parked in front of the Hall of Records about 1900. Designed by San Francisco architect Thomas J. Welsh, the Hall of Records reinforced the local government's presence in central Woodland. Beautiful terra-cotta (decorative fired clay) from Lincoln, California, manufacturer Gladding, McBean was used inside and out. (YCA.)

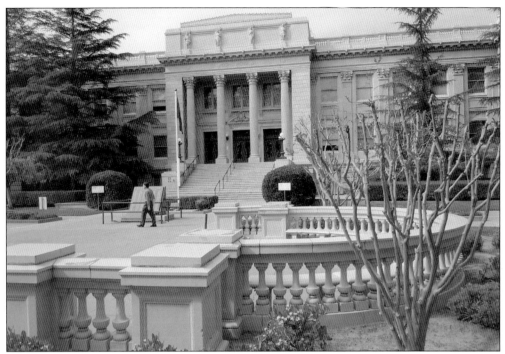

The first courthouse and the Hall of Records were demolished to build a new courthouse in 1917. Its architect, William Henry Weeks, had a reputation for producing good public buildings in small cities. He bequeathed to Woodland a lovely Neoclassical courthouse sheathed in elegant Gladding, McBean terra-cotta as well as a dozen other prominent civic and commercial structures. (DJD.)

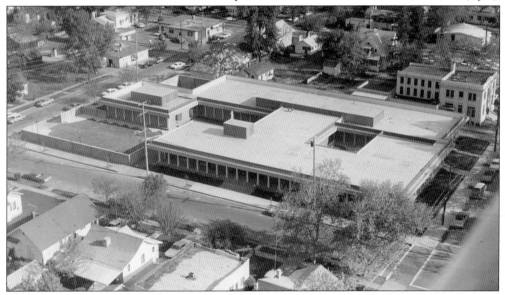

Being a county seat after World War II was a good predictor of city growth. All levels of government expanded significantly, including local government. To accommodate that growth, new facilities were needed. In 1968, this Yolo County Jail and Sheriff's Office was built on a block adjacent to the courthouse. Eventually, the facility proved inadequate, and the Monroe Detention Center was built well outside the downtown. (GHM.)

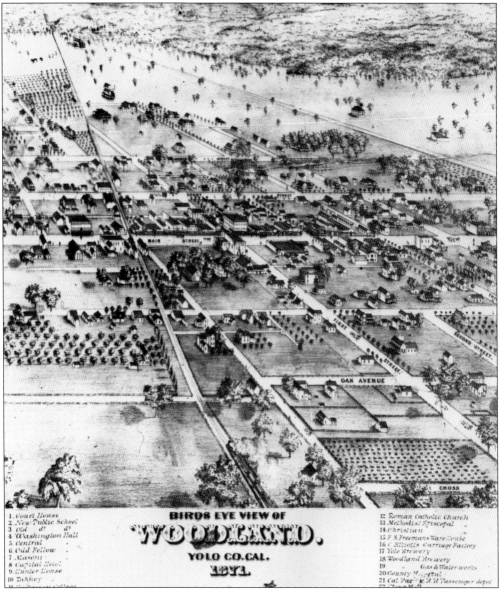

As for most small towns in 19th-century America, the arrival of the railroad in Woodland was a key event in strengthening connections and increasing the speed and scale of passenger and freight movement. Unlike most places, Woodland saw its railroad line built on one side of town in 1869, and then just three short years later, the railroad moved to a more efficient location on the other side. This 1871 bird's-eye view shows it on the west side, near today's College Street. (YCA.)

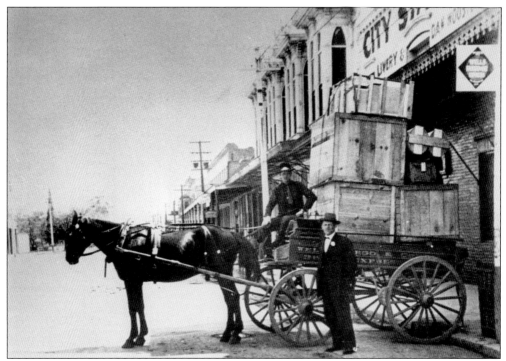

A laden Wells Fargo wagon is parked at the City Stable near Main and Second Streets. Franklin Freeman realized the importance of recruiting a Wells Fargo agency for his growing town, given its role in facilitating commerce throughout the West. In 1867, the company opened an express office at 532 Main Street, where it remained until 1918. (YCA.)

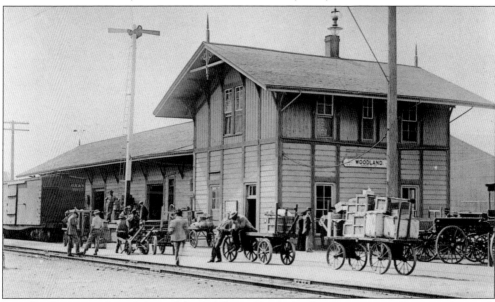

Woodland was on a branch line of the California Pacific Railroad connecting Davis in the south with Yuba City on the north. Davis was on California Pacific's main line linking Vallejo on San Francisco Bay with the Central Pacific transcontinental line in Sacramento. This depot at East and Main Streets was built when the tracks were moved to the east side of town in 1872. (GHM.)

Woodland strengthened its internal circulation when the city granted a franchise to two men to build and operate a horsecar line on Main Street. As directors, a number of prominent men oversaw the operation of the Woodland Street Railway Company during its existence from 1887 to 1897. Two horsecars ran on tracks between the train depot and Walnut Street, a distance of nine blocks. (YCA.)

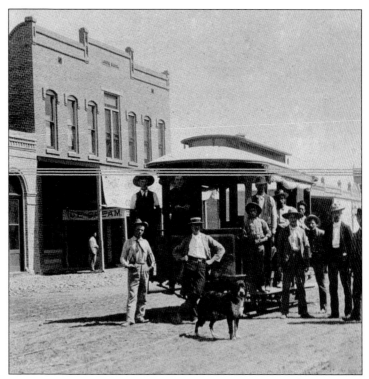

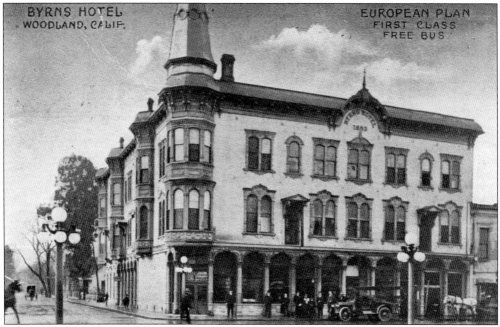

The Byrns Hotel at the southwest corner of Main and College Streets was a prominent Victorian landmark and center of social life in Woodland. Hotels, such as the Byrns and four others along Main Street (the Exchange, Capital, Craft, and Pacific House), in the mid-1880s were essential elements in the commerce of the city and its region. Many business deals were still made face to face, and traveling salesmen were common. (YCA.)

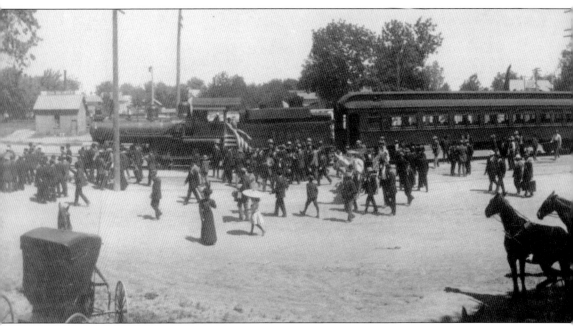

The train depot became not only the city's transportation hub but also a key public gathering place at which to see and hear important visitors. This image, in which the depot is decorated

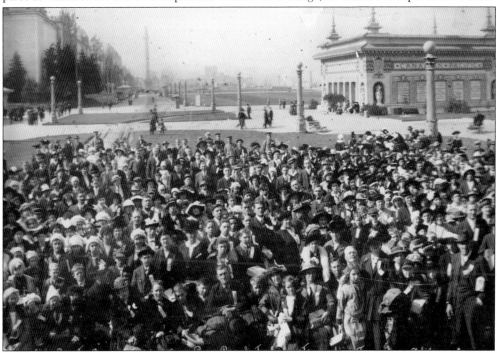

The train made it much easier for people to travel to nearby cities, as many Woodlanders did for Yolo County Day on October 29, 1915, at the Panama Pacific Exposition in San Francisco. This image is part of a larger panorama depicting the attendees from Yolo County. California counties contributed $3 million to the World Fair, expecting it to bring them flows of visitors, customers, investors, and settlers in return. (YCA.)

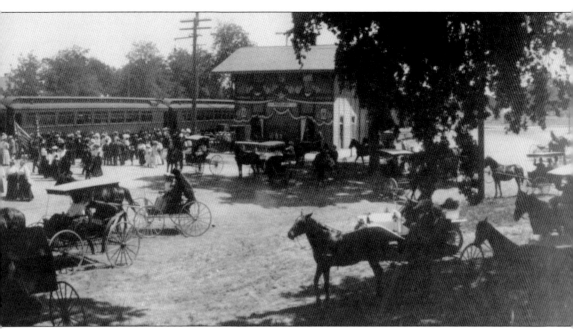

in patriotic bunting, may depict Pres. Howard Taft's stop in Woodland in 1909. (YCA.)

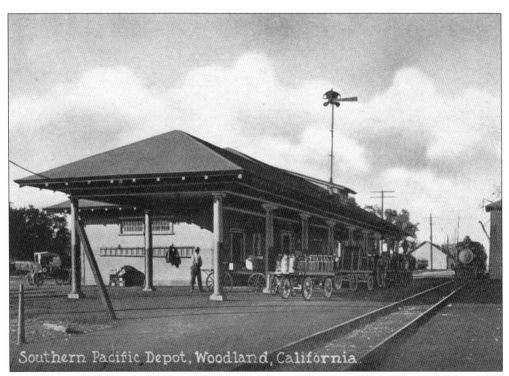

Southern Pacific Depot, Woodland, California.

The Southern Pacific Railroad built the city a new depot in 1911 after the Woodland Chamber of Commerce sent a delegation to San Francisco asking for one. A wagon with milk cans is a reminder of the importance of trains to local industries at this time and recalls the phrase "milk run." (YCA.)

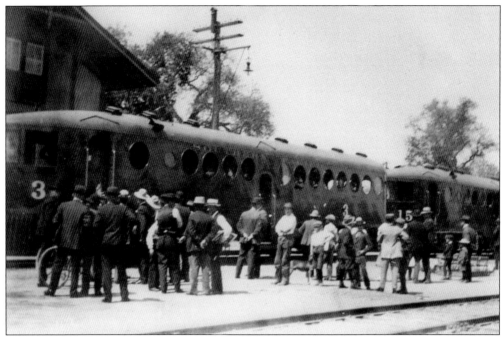

A McKeen railcar is parked alongside the old Woodland depot. These unusual motorcars—self-propelled and gasoline-powered—were made between 1905 and 1917 by Omaha's McKeen Motor Car Company. The Southern Pacific used them on local routes, including a Sunday run transporting residents of Orland, Woodland, and other small Sacramento Valley towns to Sacramento for baseball and shopping. (GHM.)

Railroads segregate land uses in cities, attracting industry and warehousing and repelling many residential and retail users. The railroad tracks and spur lines, running alongside East Street, became the major corridor of industrial land use with grain elevators and other industrial facilities filling in this open space south of the depot. East Street parallels the tracks on its east side, and highway-oriented uses, like motels and gas stations, gravitated there. (YCA.)

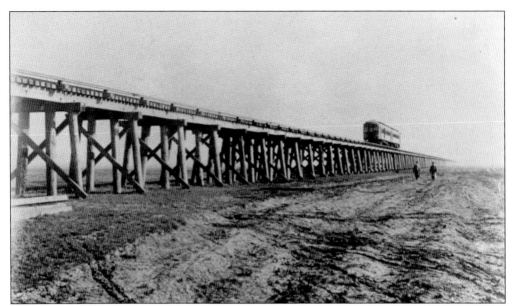

Northern California's expansive system of electric interurban trains reached Woodland in July 1912. Major new infrastructure on the route included a new M Street Bridge over the Sacramento River and this 8,000-foot trestle over the Yolo Basin. The latter is a low-lying area that had just recently been incorporated into a coordinated system of bypasses designed to protect Sacramento from flooding. (GHM.)

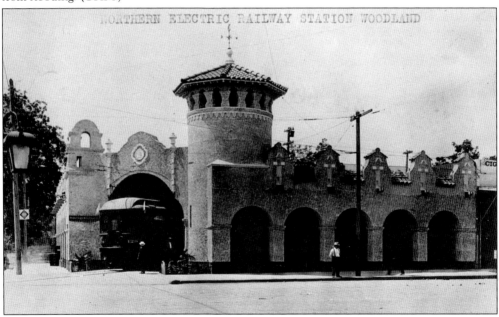

The Woodland depot for the Sacramento & Woodland Railroad (a subsidiary of the Northern Electric Railway and later sold to the Sacramento Northern Railroad) was at Main and Second Streets. The 1912 depot was a handsome example of the romantic Mission Revival style. The electric interurban connection brought customers to Woodland's businesses, students living in east Yolo County to Woodland high school, and small loads of freight from outlying farms and hamlets into town for processing and consumption. (YCA.)

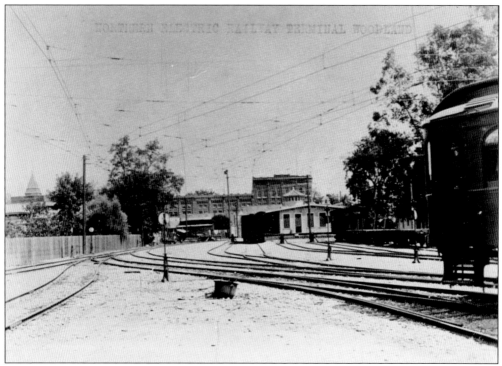

This view is of the back of the depot, with the tracks approaching it from the south. The electric interurban connected Woodlanders to employment, marketing, educational, entertainment, and shopping opportunities across Northern California, from Chico to Sacramento to Oakland. Passenger service on the Sacramento Northern to Woodland lasted until 1940; in May 1942, the tracks in Woodland were torn up and sold for scrap. (GHM.)

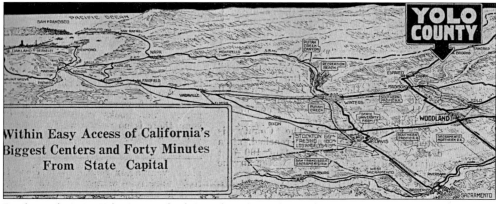

By the mid-1920s, Yolo County had 50 miles of paved state highway, 80 miles of road paved by the county, and several hundred miles of road graveled by the county. Already, some of the area's freight was traveling to Sacramento or the Bay Area by motor truck rather than via train or river. Improved roads, together with Woodland's general prosperity, stimulated the town to develop a major cluster of automobile dealerships. (WDD.)

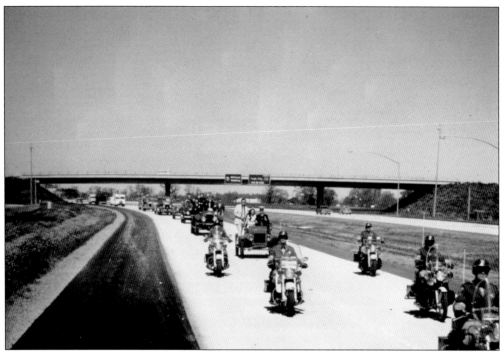

Interstate 5 through Woodland was opened in April 1973 with this cavalcade of motorcycles and antique vehicles. Interstate 5 provided a direct freeway link to Sacramento, making Woodland a more attractive commuter suburb. It also put the city on the West Coast's major freight corridor, kicking off its emergence as a regional warehouse and distribution center. (YCA.)

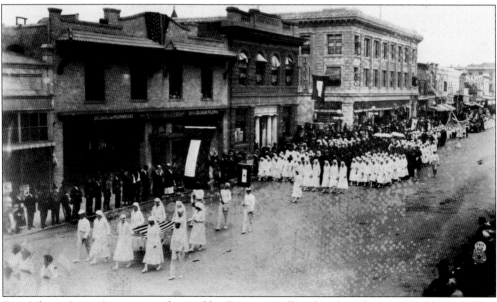

Four Liberty Loan Acts were authorized by Congress, selling bonds to finance World War I. This 1919 patriotic parade, timed to increase sales in Woodland, featured marching units from all the schools in Yolo County. Pictured is the high school forming the flag of the Red Cross in front of the 1913 Porter Office Building, the first in town to have an elevator. (YCA.)

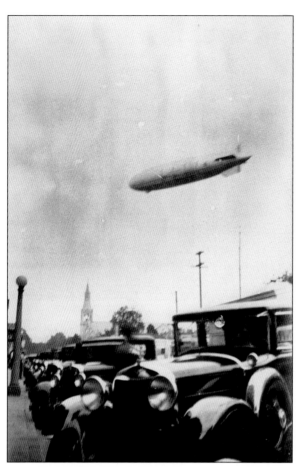

This dirigible is seen over Main Street with the steeple of Holy Rosary Catholic Church in the background. The automobiles suggest that the picture was taken in the 1920s. Surely, excitement would have been great over the local appearance of this exotic airship. (YCA.)

In 1920, O.C.W. Pratt and Arthur Huston established Fliers Field west of Woodland. In 1921, it played host to, according to the *Associated Press*, "the largest civilian air meet on the Pacific Coast." By the 1930s, the airport supported the region's agricultural economy through its seeding and dusting services. In 1952, the Watts family purchased the field, and today, Watts Field is believed to be the oldest continuously operated, privately owned public-use airport in the nation. (Courtesy of Steve Watts.)

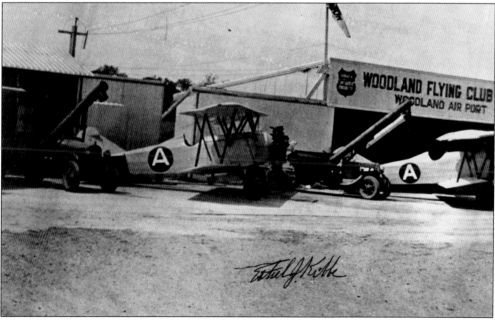

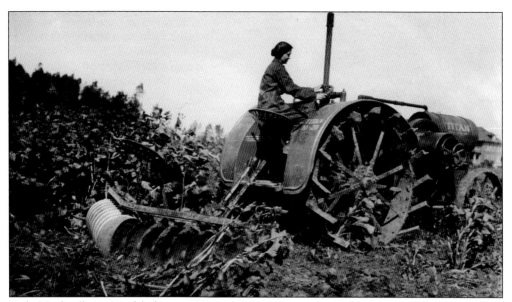

Leila Hecke (later Hardy) drives a Titan 1020 tractor on her father's farm, Yolanda, south of Woodland. She became manager of the farm's apricot operations after graduating from high school in 1918. She told the *San Francisco Chronicle,* "I can see no reason why a girl cannot think, act and execute the everyday things of life precisely the same as a boy." The war and the suffrage movement were influencing attitudes. (GHM.)

World War II airplanes named for different places, like *County of Yolo* (a B-17 Flying Fortress) and *City of Woodland* (a B-24 Liberator), helped personalize campaigns to finance the war—"let's keep 'em flying." Cities and counties were assigned quotas of war stamps and bonds throughout the war; Woodland and Yolo County, prospering from booming demands for their agricultural commodities, easily met theirs. (YCA.)

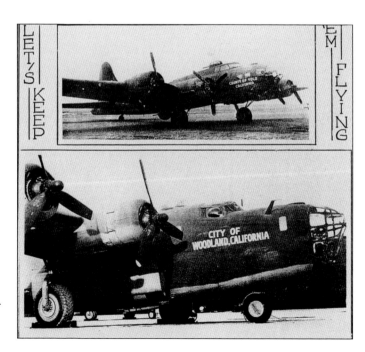

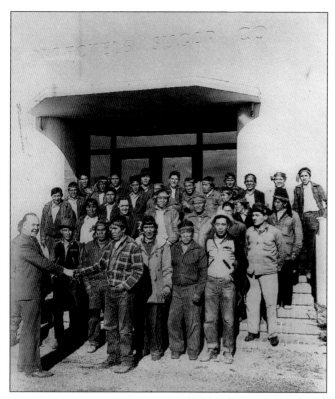

The entry of the United States into World War II in December 1941 made agricultural labor scarce. Woodland women, high school students, and retail and office workers pitched in. Some farmers arranged for Native Americans, such as those pictured here, to be bused from reservations in Arizona and New Mexico to work on their crops. Later, in 1942, the Bracero Program was established, bringing farm laborers from Mexico, a connection that would strengthen over time. (YCA.)

Dorothea Lange took this photograph at the Woodland train depot on May 20, 1942. She was documenting the evacuation of Japanese and Japanese Americans for the War Relocation Authority. More than 400 evacuees, wearing identification tags and carrying the few personal belongings allowed, boarded the train that day for an assembly center in Merced, from which they would be sent to internment camps. For many of those relocated, their connection to Woodland was broken permanently. (Courtesy of the Bancroft Library, University of California, Berkeley.)

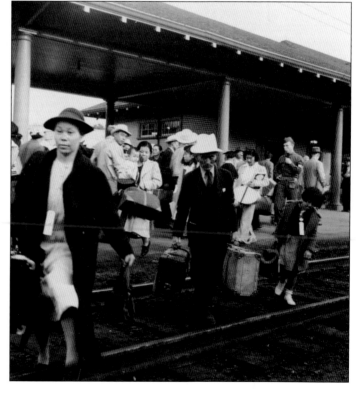

Two

MAIN STREET
ENTREPRENEURIAL SPACE

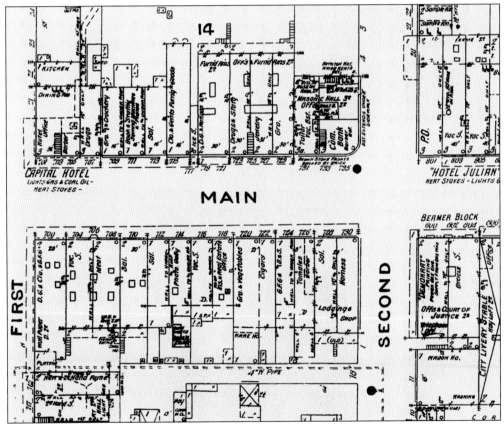

From its early days, Woodland's prosperity has been reflected in a corridor of substantial commercial buildings along Main Street. The 1895 Sanborn insurance map shows diverse business spaces along the six blocks of downtown between Walnut Street on the west and Fourth Street on the east. The block between First and Second Streets depicted here includes establishments offering groceries, candy, drugs, liquor, hotel rooms, lodging, and cigars. This commercial heart also became an important place for ordinary social exchanges and splendid parades. (UCD.)

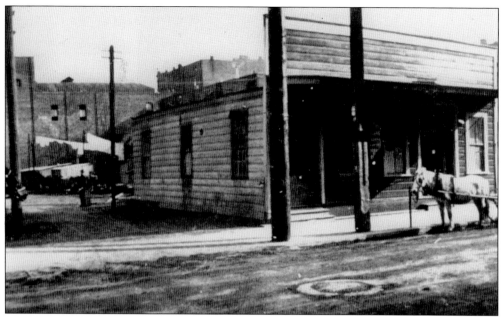

Constructed in 1853 by Henry Wyckoff as a store and saloon, Woodland's first commercial building survived 95 years and housed a remarkable number of functions. It was at times a church, the first courthouse, a bakery, and a Chinese laundry. The 1863 street grid placed it at 323 First Street and Dead Cat Alley, a half block from Woodland's future Main Street. The tall brick structure behind it is the opera house. (YCA.)

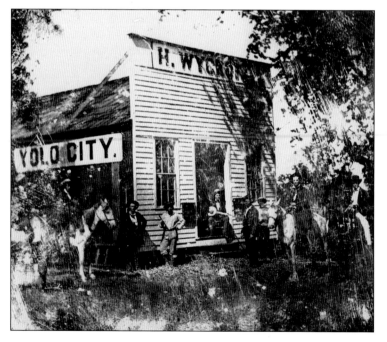

Henry Wyckoff's 1856 commercial structure had an impressive false front. It was at the future Court and Sixth Streets. Neighboring enterprises included a grocery store and blacksmith shop. The name "Yolo City" did not catch on because Freeman, not Wyckoff, did the work needed to start a real town. The building also had a short lifespan. (YCA.)

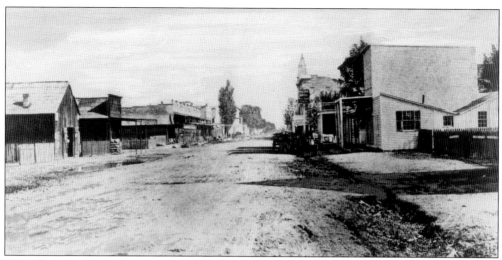

This photograph of Main Street was taken a bit later than 1883 because the Byrns Hotel tower is seen on the south side at College Street. This photograph is looking east from about Elm Street. Paving was still two decades into the future, and wooden buildings were still common. Some building owners have provided wooden arcade shading over their sidewalks. The 1886 Sanborn map shows about 125 commercial or residential frontages between Walnut and Fourth Streets on Main Street. (YCA.)

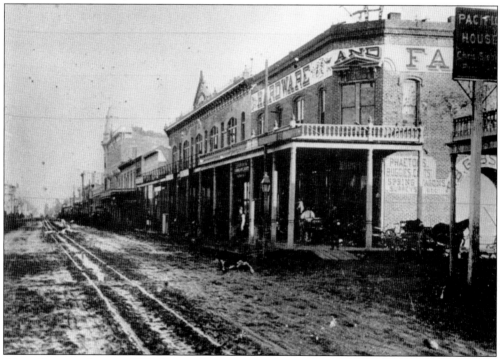

About five years later, in 1890, here is the same easterly view from Elm Street. Gibson's Hardware and Prior's Block are two-story brick buildings added between 1886 and 1889. The rails of the horse-drawn streetcar are visible in the muddy street, a line that connected the train depot east of downtown with the town's premier hotel, the Byrns. The 1889 Sanborn map shows about 150 commercial or residential frontages downtown, a 20-percent growth in three years. (YCA.)

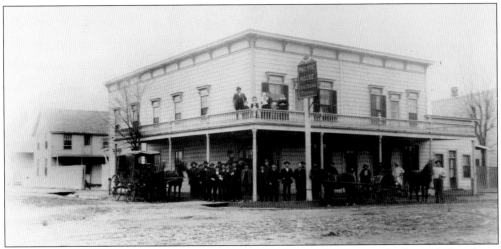

The Pacific House, at the southwest corner of Elm and Main Streets, was built in 1869 and was replaced by an automotive garage in 1917. It featured a large saloon, but most of the space was devoted to rented lodging above and a dining room and adjacent kitchen below. This photograph shows 31 people, including a well-dressed family on the balcony. The sign indicated that the proprietor was Chris Sieber, a German in a town where Germans were prominent. (YCA.)

Like other retailers, grocery stores were located on Main Street in 19th-century Woodland. The era of dispersed supermarkets was five decades in the future. Here, George Hatchis, the proprietor of Best Grocery, shows off his children and his handsome delivery cart. His canvas sunshade protects his fruit and other wares from the intense Central Valley summer sun. (GHM.)

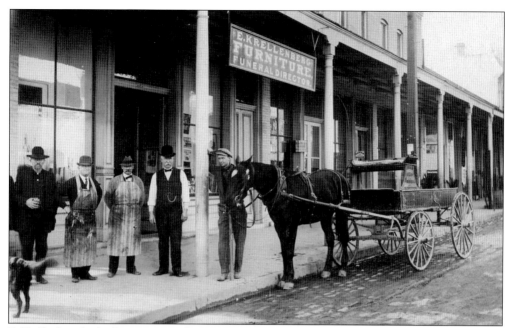

E. Krellenberg had a furniture store beginning in 1869 and later added the funeral director function. The delivery wagon gives a telephone number for the firm—dial 1081 for undertaking services—so this photograph is from after 1884 when the city's first telephone exchange was started. (GHM.)

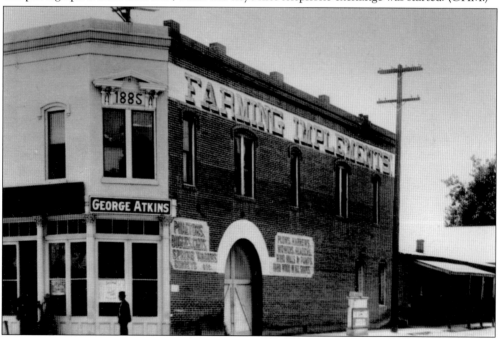

The George Atkins Farming Implements store succeeded Gibson Hardware at its Elm and Main Streets location of 1885. A smaller building along the alley in the back was, in 1895, a harrow store, which was a specialized agricultural machinery niche. By 1925, the main building was being used as a movie theater that was known as the Yolo Theater when it burned in 1964. The alley structure did not "go Hollywood" but was in 1925 still a machine shop. (GHM.)

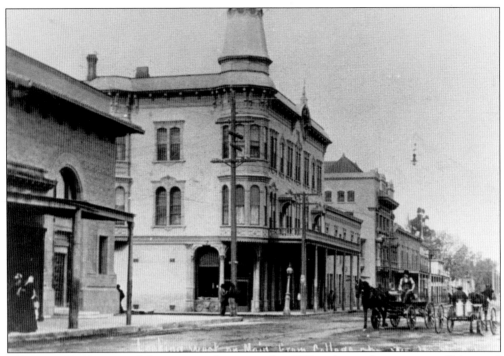

The Byrns Hotel was a stylish structure when erected in 1883 at the southwest corner of Main and College Streets. Its fourth-story tower rivaled the steeples on some of the town's early churches. It was a social epicenter and popular meeting spot until it was removed for the even grander and larger Hotel Woodland (1928). To the east and across the intersection (foreground, left) is the 1907 Bank of Yolo, elegantly styled in the manner of Chicago's Louis Sullivan. In 1961, the bank received an unsympathetic makeover. (GHM.)

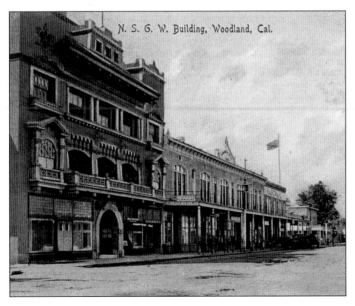

Another "noble pile" was added to the western side of downtown in 1904 when the Native Sons of the Golden West (NSGW) gave themselves an ornate four-story clubhouse and profit center. The facade was a bit outrageous, almost postmodern in its combination of Mission and Classical elements. The economic life of the NSGW's investment was not outstanding either. It was shortened to one story in 1962, housing Timothy's Bakery at 422 Main Street. (YCA.)

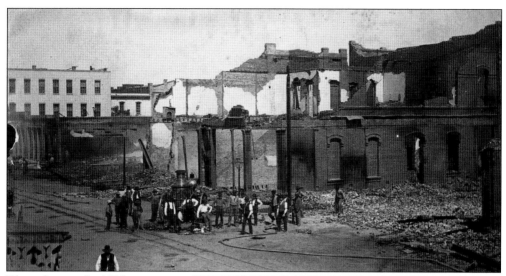

Three fires in the 1890s challenged the town's ambitious growth, although the recovery produced some tall and stylish constructions, particularly after the turn of the century. The 1892 fire (illustrated here) was massive; fueled by a July wind, it destroyed two square blocks north of Main Street and 18 structures to the south. The grand opera house of 1885 and the Masonic Hall were among the big buildings wholly victimized. In 1895, fire destroyed the flour mill at Court and First Streets. In 1896, Laugenour's new woolen mill burned. (YCA.)

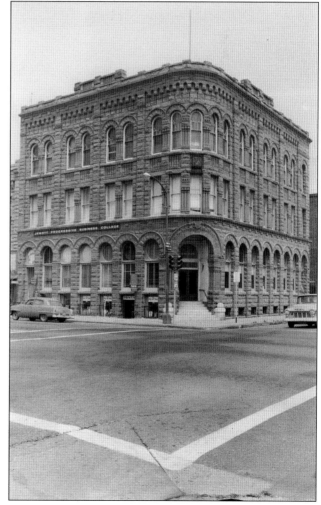

Built at the northwest corner of Second and Main Streets in 1893 after the big fire, the Farmers and Merchants Bank was the pride of the town in red sandstone and Richardsonian Romanesque styling. Local big names organized the financial institution and funded the building: Hershey, Beamer, Diggs, and Jackson. The Masonic Lodge had the third floor. It was known as the Elliott Building in 1970 when demolished. (GHM.)

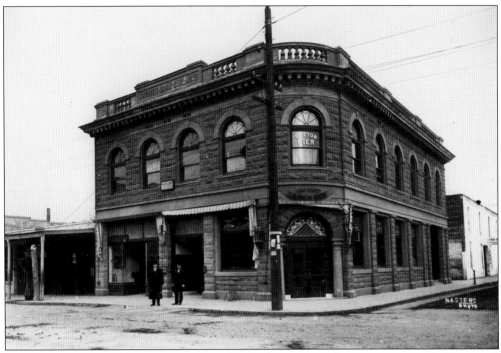

Built in 1903 as the Yolo County Savings Bank, this was another impressive work for a small town. The architect and builder were San Francisco's top talents. Sandstone construction and Romanesque design were hot at the time. Copper and marble trim and Tiffany-style windows were conspicuous luxury features. The building lost its rooftop balustrade for safety reasons, an unfortunate decapitation, and ceased being a bank in 1963. (YCA.)

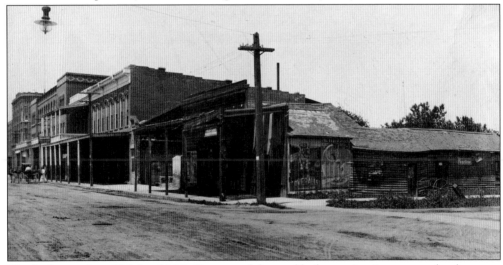

This looks west from Third and Main Streets and shows a block experiencing uneven development. The sway-backed buildings in the foreground were, for decades before this 1899 photograph, a Chinese washhouse, dilapidated stables, and a tenement (according to Sanborn maps). At that spot arose the four-story Odd Fellows Lodge in 1905. Visible at the west end of the block is the 1894 Julian Hotel, a stylish three-story, multiple-use structure built in the postfire boom. Note the streetlight, one of five installed in 1877. (GHM.)

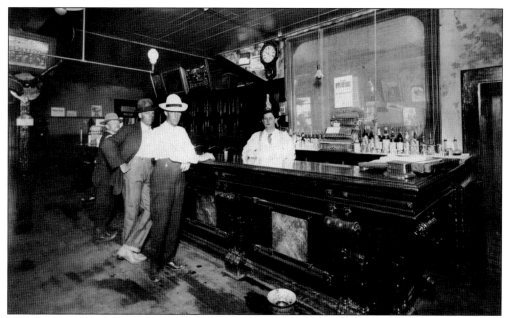

This undated photograph shows the interior of a saloon with B. Germeshausen as bartender. Bars were lively and attractive places to their patrons. But they were a bane to Woodlanders who favored prohibition and "anti-saloon" measures. The 1886 Sanborn map shows 25 "saloons," "sample rooms," or "liquor" establishments. The numbers fall a bit to 20 in 1889 and 19 in 1906. Then the temperance movement and Prohibition caused downtown commercial buildings to lose a major tenant. (GHM.)

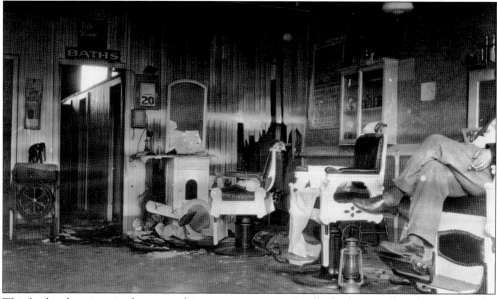

This barbershop interior has several interesting aspects. It offer baths as well as shaves, with the bathing rooms visible in the left rear where both tubs and showers are available. There apparently has been a recent explosion, probably the water heater, to the rear of the room where the wall is damaged and debris remains. The calendar, from the Electric Garage, says it is November 20, 1928. (YCA.)

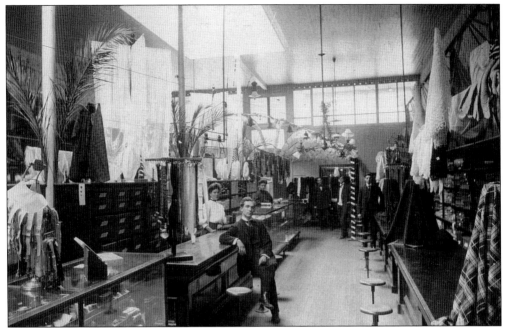

In 1907, the Arcade was a high-end "dry goods and clothing" store at 529 Main Street. All six clerks, and the store's tasteful interior, communicate that theirs is clearly the place where wealthy Woodlanders shopped. The seated clerk, Clyde Osborne, was practicing his haughty demeanor. (YCA.)

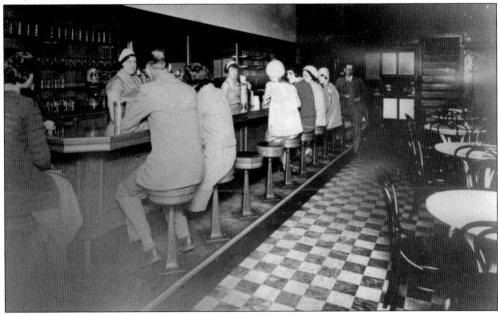

This soda fountain and lunchroom operated from 1929 to 1941 as the Sanitary Dairy's retail outlet, joining the creamery, which was open since 1917. The proprietors, Asa W. Morris and his son Frank, were world famous for their prize-winning dairy cattle. The creamery was in the heart of downtown, next door to Corner Drug at the southeast corner of First and Main Streets. In 1941, it moved to Sixth Street and Lincoln Avenue in the town's industrial district. (YCA.)

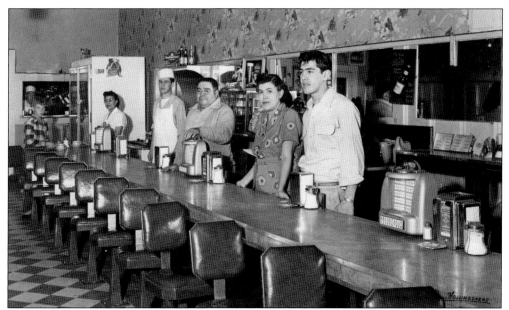

Restaurant staff, owners Melchor and Otilia Contreras (at the right), and their son Fred stand behind the counter at La Villa Café at 420 First Street in 1953. Otilia Contreras was the first Mexican woman in Woodland to open and run a business, which she did from 1950 until 1975. The restaurant attracted a diverse crowd, from kids coming by after school for a tortilla with molé to movie stars, such as Clark Gable, in the area to go hunting. (Photograph by Paul W. Hollingshead, courtesy of Rachel Contreras Mallery.)

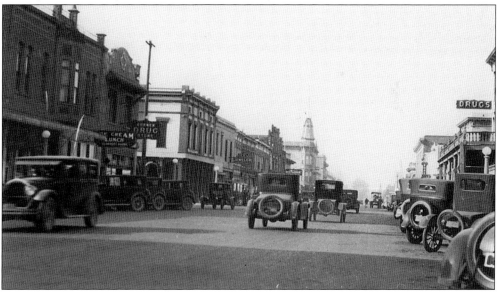

Main Street has become automobile space in this 1920s photograph looking west at First Street. On the left, the Morris Dairy "Ice Cream and Lunch Shop" has not yet become Sanitary Dairy. Corner Drug on the left has gained its current Mission Revival building exterior. The distinctive Victorian tower of the Byrns Hotel in the center background has not yet given way to the 1928 Hotel Woodland. The original 1906 paving may have been redone, and many aging wooden arcades have been removed as part of a clean-up campaign. (GHM.)

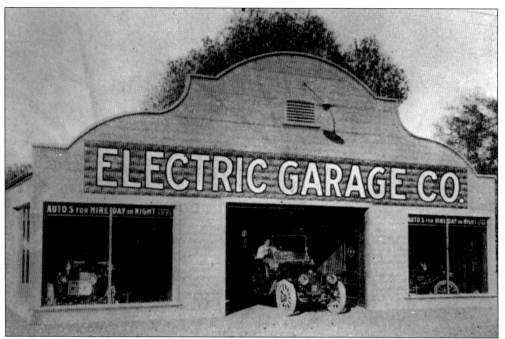

This Mission Revival facade constructed in 1912 became the gateway to the largest single automotive repair space in Northern California. The Electric Garage specialized in automotive electrical systems. It also sold cars and was the Studebaker dealer when Studebaker made electric cars. A Dodge-Chrysler franchise survived on this site until 2011. (YCA.)

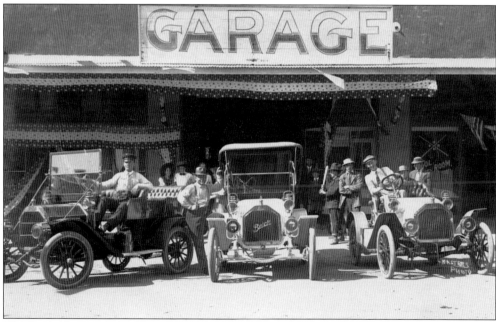

This new garage on Main Street, shown here in 1910 with three new Buicks, was helping establish downtown Woodland as a major automobile dealership row for the Sacramento Valley. By 1925, there were eight dealers in the downtown, in clusters east and west of the center. Note that two of the three cars here still have right-hand drive. (DH.)

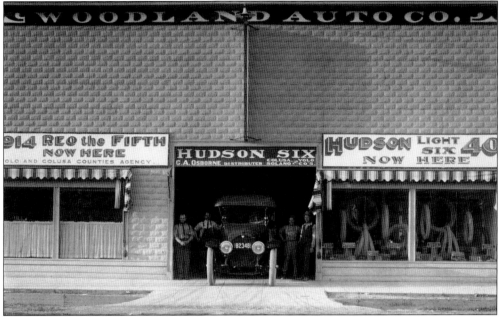

By 1914, the east side automotive cluster included the Woodland Auto Company selling the latest Reo and Hudson cars. The sign says C.A. Osborne is the distributor for three counties: Yolo, Colusa, and Solano. The firm is between Third and Fourth Streets on Main Street, just east of the Electric Garage shops. (YCA.)

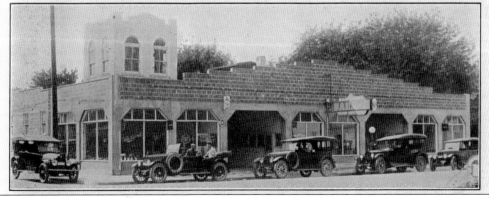

In this 1920 advertising photograph, the Main Street Garage has a more elaborate building, including a tower. The brands sold here are Packard, Hudson, and Essex—prestige models at the time, suggesting a wealthy stratum in Yolo County society. (WDD.)

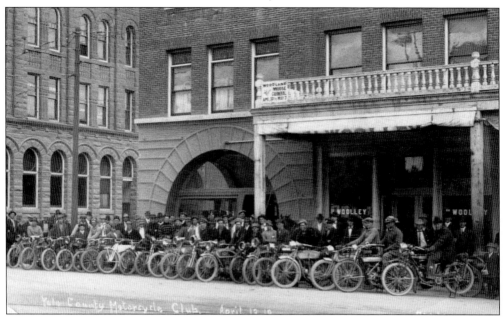

A score of motorcycles is assembled for a Sunday rally on April 13, 1919. The setting looks cosmopolitan and almost "big city." The backdrop consists of two of Woodland's three-story buildings, the Elliot Building (rear), and the Julian Hotel. Their destination is certainly the countryside and perhaps the almond orchards blooming in western Yolo County's Capay Valley. (DH.)

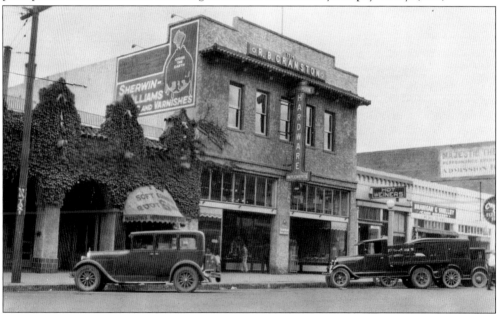

A particularly well-remembered store was Cranston's Hardware located between First Street and Second Street. Reuben Cranston worked part of his first two decades in town for the Diggs hardware business across the street and started his own in 1898. The building depicted here was built for his expanding business in 1914. The photograph dates from about 1925 when sharing space on the block were a grocery, bakery, movie theater, train depot, electrical supplies, a drugstore, and "Hot Wieners." (GHM.)

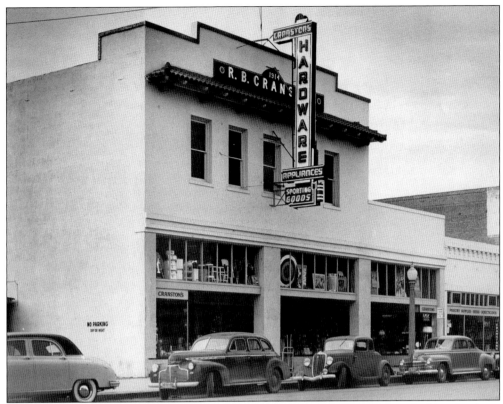

Twenty years later, around 1948, the Mission Revival trim on the 1914 Cranston Building has been complemented by an in-character stucco exterior. Poultry Supplies are now offered next door, and the train depot is gone. The big sign now advertises appliances and sporting goods. The hardware and farm implements outlet has become somewhat of a department store. (GHM.)

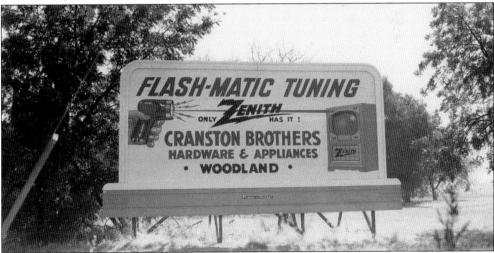

This billboard at Brown's Corner (Main Street and Road 98) advertised Cranston Brothers as an appliance store with the latest in remote-controlled televisions. This dates the sign to 1955 when Zenith had the first device, as the print advertisements bragged, to "shut off long, annoying commercials." (GHM.)

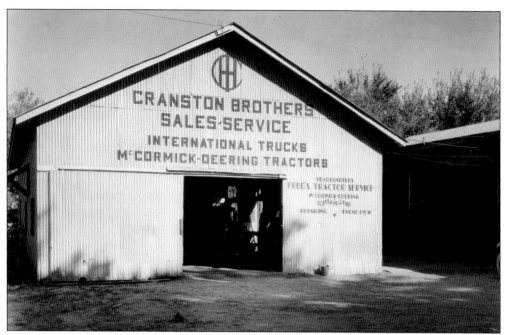

"Back stage" elements, like this service shed, supported the compact Main Street storefront with the workspace and parking required for Cranston's diverse operations, including farm equipment repairs. The lack of parking in front of Main Street stores was a much-discussed problem in traditional downtowns all over the country. Cranston Hardware closed in the 1990s. (GHM.)

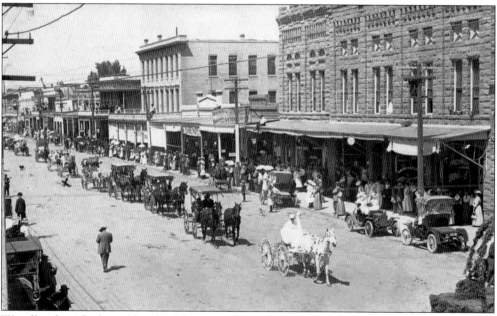

Woodland might be said to be "the city of parades" judging from the scores of surviving parade photographs. Main Street, between Second and First Streets in this photograph, provides a terrific backdrop. The great sandstone blocks of the Diggs-Leithold Building (1893) could not be more impressive. The parade has decorated floats (far right) and a whimsical "Mother Goose." (YCA.)

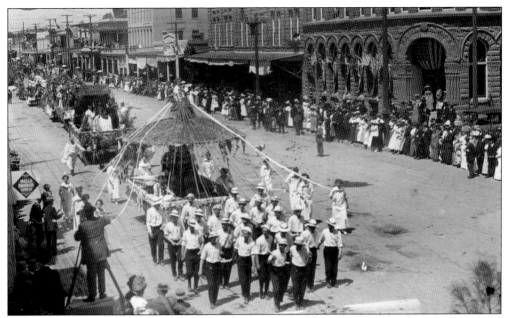

This parade has many spectators and a half-dozen decorated floats visible in the space of a block. The abundance of flags suggests the Fourth of July. Note the photographer in the lower left and the people watching from the roofs of the wooden sidewalk arcades. Much of downtown got paved streets around 1906; this section is clearly paved, although with visible potholes. (YCA.)

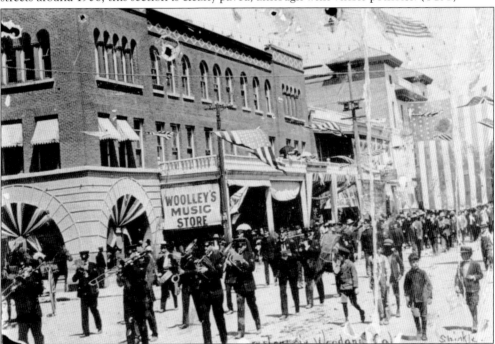

Marching bands are a big part of the national tradition of Fourth of July parades. This undated photograph juxtaposes a large band with another, literal sign of Woodland musical culture: Woolley's Music Store, seen here among Julian Hotel's ground-floor shops. Julian Hotel's corner rental space is occupied by the post office, making this a busy intersection. (GHM.)

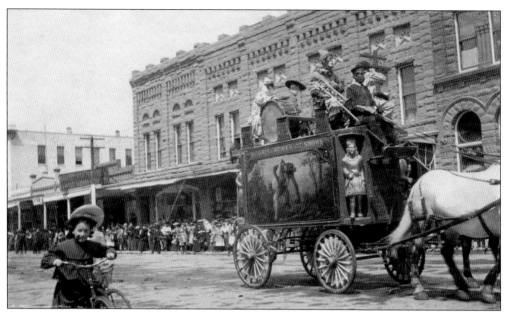

The circus came to town on April 20, 1906, and paraded down Main Street. Drawing a crowd to see a sample of its circus menagerie, this is Norris & Rowe's New Big Show. Another popular entertainment, the Chautauqua, came to Woodland in late spring for about a decade, ending in 1924, and sometimes their stars arrived to a parade-like atmosphere. (GHM.)

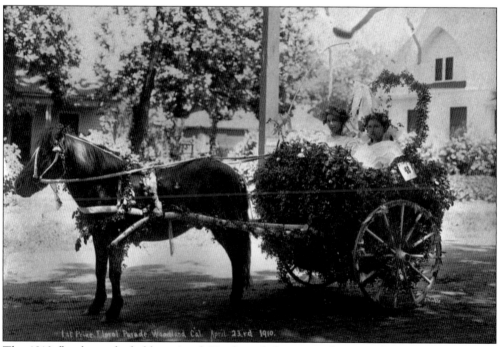

The 1910 floral parade, held on April 23, elicited this entry that won first prize. Pulled by a decorated pony, Alice Dingle Reith and Gladys Younger Merritt sit in a two-wheeled cart. Both girls wear classical robes, a frequent parade motif. Theirs is entry No. 48. (YCA.)

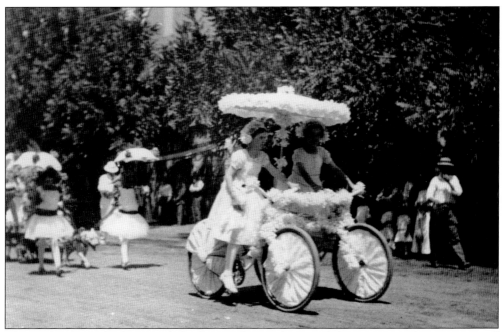

This undated parade photograph (perhaps as late as the 1940s) features two girls on an unusual two-bicycle rig. An enthusiastic German Shepherd follows, pulling a wagon. (YCA.)

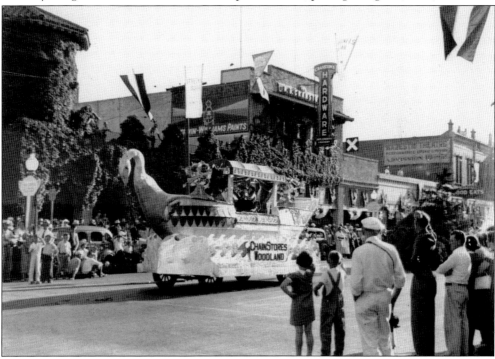

This parade in the late summer of 1937 celebrated the opening of the Spreckels Sugar factory. The parade and festival attracted thousands. This wonderful float has a fanciful dragon creation. That was bold, given that its sponsor was the Chain Stores of Woodland. Chain stores were accused of gobbling up local merchants, a concern that lives on. (YCA.)

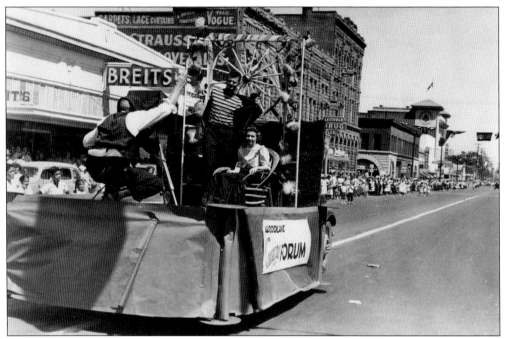

The parade entry featured here is by the Woodland Camera Forum. The Camera Forum has been in existence since 1940 and has included talented amateurs using state-of-the-art cameras as well as professional photographers. The float shows portraits being taken, but landscapes dominate the Forum photographs that have survived through the years. (GHM.)

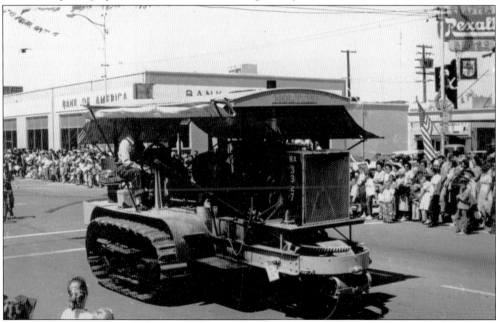

This Fourth of July parade from the early 1960s features a massive Holt 75 crawler-type tractor trundling along farther from the blocks at the center of town that were shown in earlier parade images. This is near Cleveland Street, west of the core. The new suburban-style Bank of America is prominent. (GHM.)

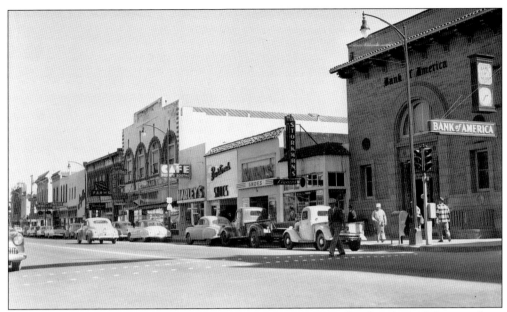

Main Street is shown in 1951 at the peak of its importance to Woodland in this and the next three photographs. They show how well maintained and busy the corridor was between Walnut and Fourth Streets. Individual stores upgrade their building facades and signs. The mix of businesses is rich. This view looks southeast from College and Main Streets. (UCDSC.)

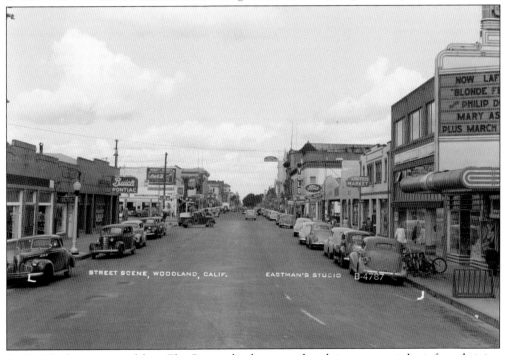

In 1946, looking eastward from Elm Street, the diverse and evolving economic basis for a thriving Main Street is shown. On the left and right are automobile dealerships. On the right is a pair of movie theaters, the Yolo and the State. Food markets, cafés and restaurants, a bakery, hardware store, hotel, gas station, and clothing shops are advertised. (UCDSC.)

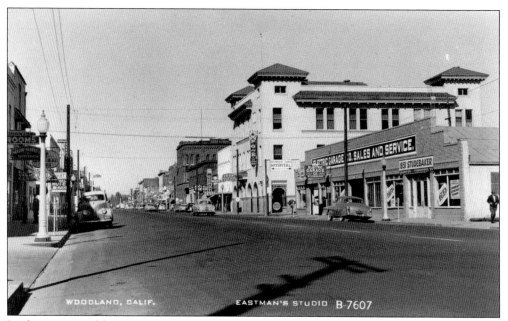

Looking westward from Fourth Street, the Electric Garage is thriving in 1951, and the Odd Fellows Hall looks to be in perfect shape. Paving is in good condition and parking meters are regulating the vital commodity of space on the curb. Many of the enterprises are automobile related on both the east and west edges of downtown. (BWG.)

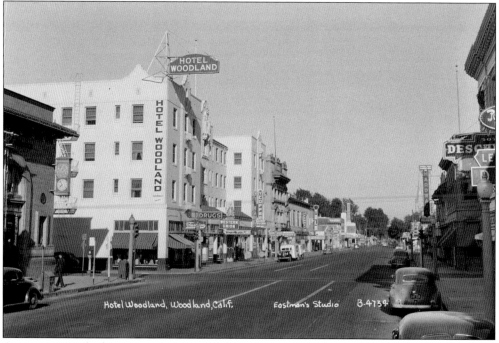

Again in 1946, looking westward from College Street, the 80-room Hotel Woodland with its Spanish Colonial Revival styling looks in prime condition. The 1904 Native Sons of the Golden West Building to the west of it is still 15 years from its radical reduction in height. Fifty years later, this same view would show some vacant lots. (UCDSC.)

Undermining old Main Street have been rival locations with free parking, less congestion, and lower land costs. Here is Jack's Lunch at Cottonwood and Main Streets along a major westward sprawl of diverse enterprises. The lunchroom is adjacent to a gas station and the West Woodland Market offering fruits and vegetables. (YCA.)

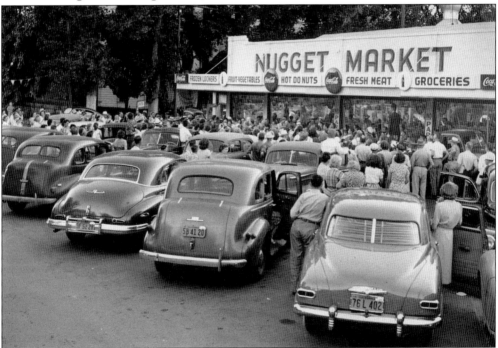

In 1926, Nugget Market was opened at 416 Main Street in the 1889 Gibson Block by father and son William and Mack Stille. In 1946, it moved westward into this freestanding structure with off-street parking at 157 Main Street, the site of the Yolo Brewery. Nugget's greatly enlarged Woodland market is still at this site, and eight other Nuggets are operating in other cities in the region. (Courtesy of Nugget Market.)

R & X TAFOYA

RUBEN & XAVIER
145 EAST ST. • WOODLAND, CA 95776-3310
(916) 662-1793

Near Court Street on East Street, Tafoya's Scales and Tafoya's Drive-in Market date from 1947 and 1949. The truck scales, which mainly weighed loads of tomatoes for local farmers, were well located on what was then Highway 113, as most loads were headed out of town. Owners Ramon and Lupe Tafoya were a community resource to their English- and Spanish-speaking customers, many of whom lived on the east side of town. (Courtesy of Stella Tafoya.)

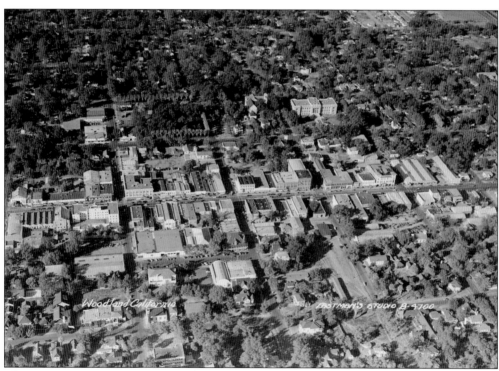

This 1946 aerial photograph emphasizes the magnitude of the downtown Main Street commercial corridor at its peak. Sizable buildings often occupied not only the lots facing Main Street but also those north of Dead Cat Alley (facing Court Street) or south of Dog Gone Alley (facing Lincoln Avenue), especially along the six blocks between Fourth and Walnut Streets. (UCDSC.)

Three

INDUSTRY
JOBS AND A SKYLINE

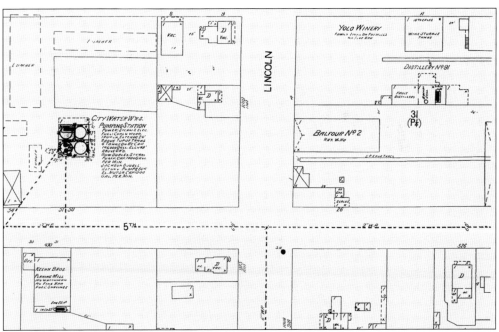

Woodland's manufacturing activity has been primarily food- and agriculture-related with a strong secondary base in woodworking and construction-related activity. This image from the 1906 Sanborn insurance map shows some of the score of lumber sheds and planing mills in the industrial district east of downtown. The Yolo winery has a distillery. Grain and hay warehouses of a modest scale were common all along the railroad spur tracks. Not shown are the nearby stockyard, creamery, olive press, and fruit sheds. (UCD.)

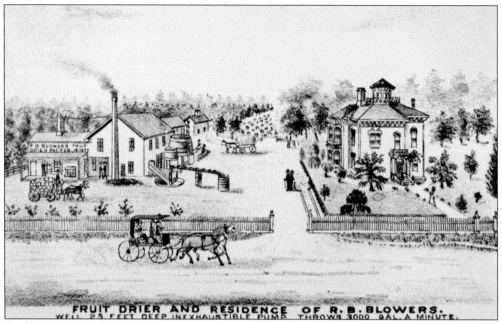

On his 80 acres at the edge of town, Russell Blowers produced California's first commercial raisins and olive oil and some of its earliest dried fruit. Blowers won awards, fame, and respect statewide. His raisins were judged best in the world at the Centennial International Exhibition of 1876 in Philadelphia. He adopted innovations, including steam-driven pumps for irrigation and the drying building shown in this 1879 image. (YCA.)

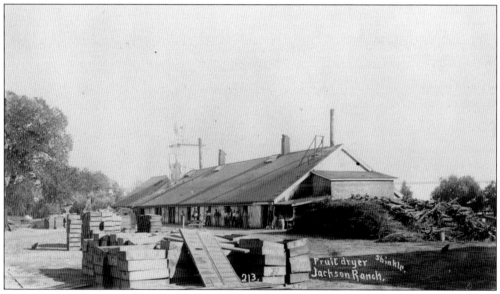

Another early fruit producer was the Yolanda Ranch, located two miles south of town. The proprietors, Byron Jackson and later George Hecke, were famous and well connected. By 1884, an architect-designed mansion showed off the wealth gained from fruit and mechanical innovations, such as an irrigation pump sold worldwide. Byron Jackson operated his 1872 blacksmith shop and foundry in Woodland just a block from the commercial center of town. The stacks of wood will be used in the fruit dehydrator. (YCA.)

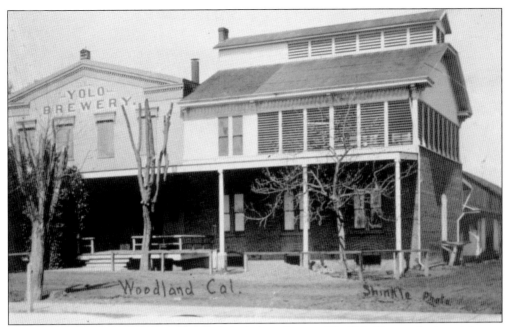

Germans were leaders in beer and distilled alcohol production. The Yolo Brewery had an elaborate 1868 brick building with subsequent additions by the Schuerley and Germeshausen families. The rival Woodland Brewery was located nearby in 1869; both were on the west edge of downtown. A notable fire in 1934 damaged the landmark structures and adjacent properties. Woodland became no Milwaukee. (YCA.)

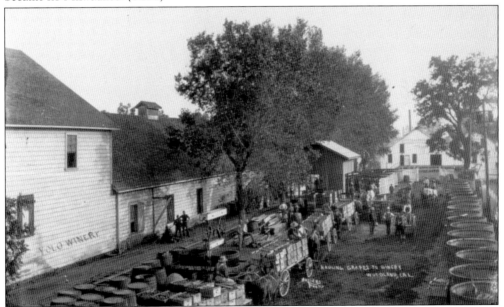

In 1884 and 1885, Woodland gained the Yolo Winery and Woodland Winery. The trackside location near the Southern Pacific depot aided distribution of Woodland-produced wine and spirits. V. Santoni's popular olive oil press was nearby (from 1896 to 1951), presaging today's linkage between olive oil and wine marketing. The anti-saloon movement, Prohibition, and competition from other grape districts stifled the local wineries. Woodland became no Lodi. (YCA.)

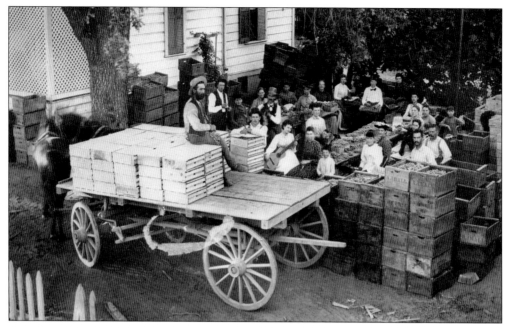

The Bidwell family members are packing table grapes for market during the 1890s in the large yard of their Woodland home and orchard. Alice Snavely, from a musical family that owned a winery in town, is shown with her guitar and her son Swain. The fruit crate labels indicate that A.J. Rall took the grapes to market. (BWG.)

Not until 1895 was a large commercial creamery built in Yolo County. The Woodland Creamery was at Sixth and Cross Streets, located in the nascent trackside industrial district. Churns are shown in the butter-making room in 1905, which was when Harry Stirling Martin was the butter-maker. The creamery, a cooperative, was built with funds raised from local dairymen. A statewide drive to modernize California's dairy industry generated the nearby University Farm School at Davis in 1907. (GHM.)

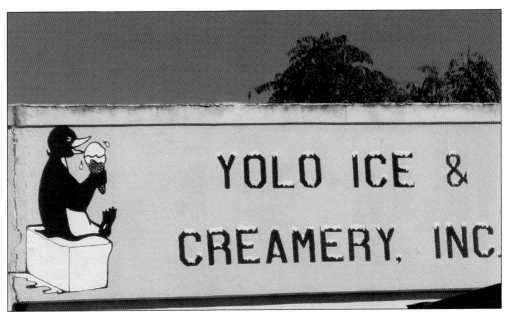

Before refrigerators, Woodland's Union Ice Company at Sixth Street and Lincoln Avenue supplied "Crystal Pure Ice" to much of Yolo County as well as communities in Solano and Colusa Counties. Later, Yolo Ice and Creamery occupied this site, where the pictured sign may still be found. (DJD.)

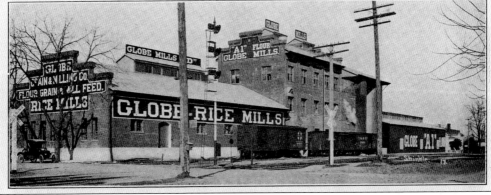

Grain milling, initially of wheat and barley, began on a big scale west of downtown (Court and First Streets) at the Sacramento Valley Roller Flour Mills. Woodland Grain & Milling (later Globe Rice, seen here) was built in stages starting in 1904. Its location at East and Court Streets started an east-side, rail-oriented cluster of large grain-handling structures. The Rice Growers Association used the mill for three decades until closure in 1980. Renovations for a mixed-use space preserved the structure. (WDD.)

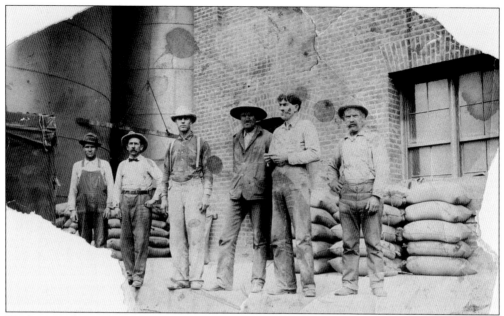

Workers stand near the silos at Globe Mills. The tradition of using 100-plus-pound sacks for grain (and nearly that weight for flour) made it demanding work in an often-dusty environment. (GHM.)

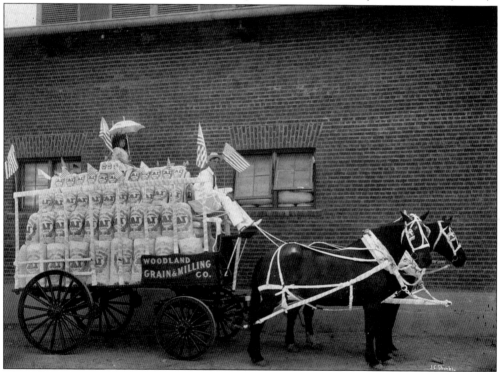

This advertising photograph is undated but may have been taken in conjunction with a parade. The Globe Mill's original name is on the wagon: Woodland Grain & Milling Co. "A-1 Flour" was the product name painted on the building for many decades and used in local advertising, often employing a "buy local" theme. (YCA.)

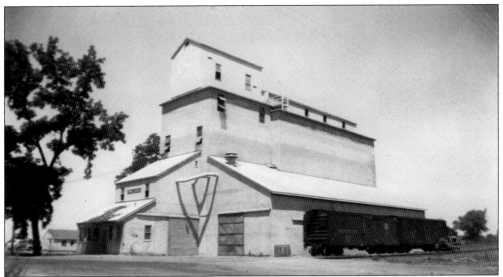

Rice became an important crop in Yolo County following 1915, with sacks produced multiplying a hundredfold during the next decade. This photograph from 1946 shows the Paulson & Christenson Rice Mill, one of several large mills located in the East Street railroad corridor. Rice mills and church steeples long created the high points in Woodland's skyline. (DH.)

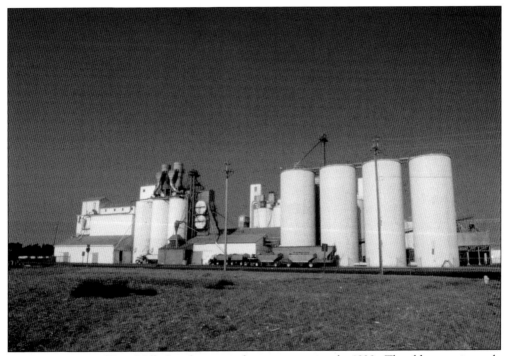

Pacific International Rice Mills, Inc., has grown by accretion since the 1930s. The oldest continuously operating rice mill in California, its best-known product is medium-grain Calrose rice. A subsidiary of Anheuser-Busch for some time before being sold in 2010, it also processes rice for the brewing industry. Dominating Woodland's northern skyline, especially from Interstate 5, it contributes significantly to the town's agricultural iconography. (YCA.)

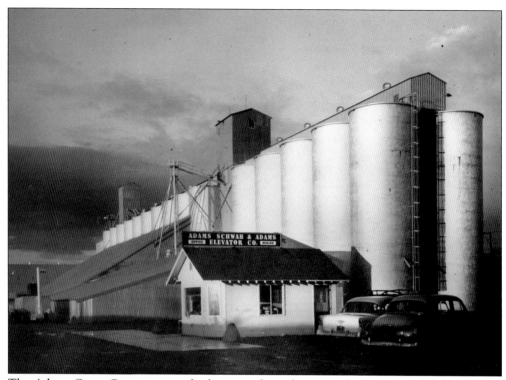

The Adams Grain Company was the largest independent grain brokerage in California. This view of its major storage and handling structure on East Street is from the 1950s when the firm was "Adams, Schwab & Adams." Starting with malt barley, the firm later handled wheat, corn, safflower, and other grains. Buying from thousands of farmers, the company sold to feedlots, dairies, and poultry farms. (JBA.)

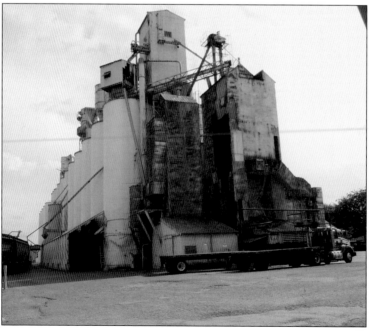

Adams Grain is now part of the Adams Group, headquartered north of Woodland in Arbuckle. The firm still owns its old East Street elevator, seen here in a 2011 photograph, and a second facility in Woodland that processes and distributes seed for planting in the Central Valley and beyond. Seed research, production, and distribution are important agricultural activities in Yolo County today. (DJD.)

City Water Works was a large structure looming over downtown. Located northeast of Lincoln Avenue on Fifth Street, it was built just before 1895 to supplement the earlier Woodland Water Works tanks on Main Street near Fourth Street. Used mainly during the summer, it was surrounded by piles of fuel wood for its steam-powered pumping station. Local boosters (Stephens, Franklin, and Laugenour) led investment in this vital utility after 1880. (GHM.)

Woodland Gas Works, located at the southeast corner of Fourth and Main Streets since 1874, used coal to produce gas that was then piped around town. By 1877, the city used this gas for five streetlights at intersections along Main Street from College Street to Fifth Street. In 1901, ownership went to the company that became Pacific Gas & Electric (PG&E), which also operated an electricity plant on Sixth Street northeast of Lincoln Avenue. Note in this undated photograph the tall smokestacks, which reflect efforts to disperse pollutants. (GHM.)

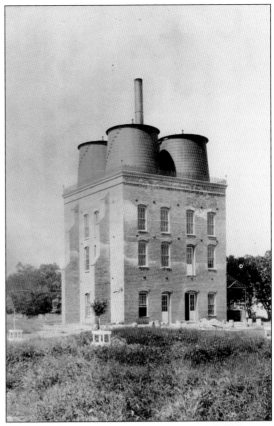

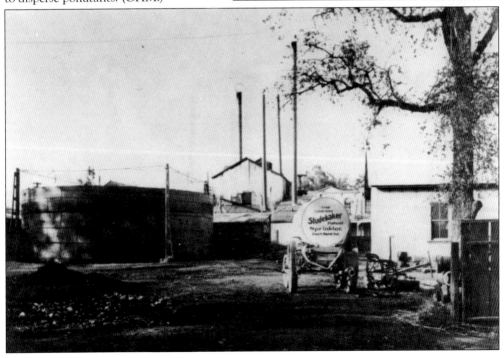

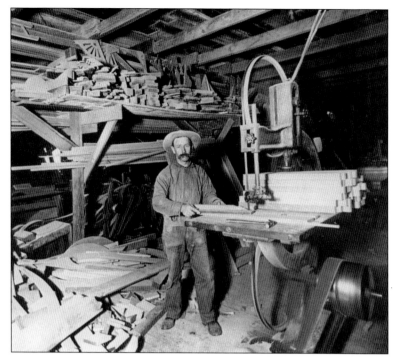

Gus Keehn is depicted here at work in 1908 in the City Planing Mill on Fifth Street southwest of Main Street. Decorative trim as well as doors, windows, and cabinets for the town's homes came out of this shop for two decades. Five Keehn brothers were all involved in building Woodland houses and other structures. (YCA.)

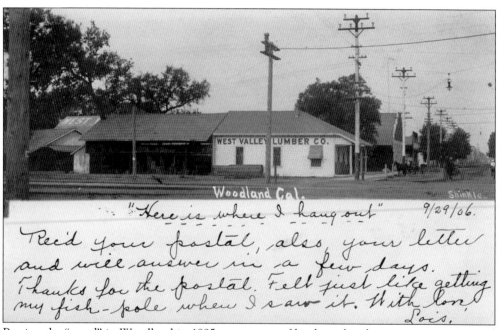

Woodland Cal.

Shinkle

"Here is where I hang out" 9/29/06.

Rec'd your postal, also your letter and will answer in a few days. Thanks for the postal. Felt just like getting my fish-pole when I saw it. With love, Lois.

Putting the "wood" in Woodland in 1895 was a score of lumber-related structures concentrated just south of Main Street between the Keehns' mill and the Southern Pacific depot. This 1906 photograph shows part of the largest group of lumberyard structures, the West Valley Lumber Company. Lumberyards and planing mills appear in many locations in the first Sanborn insurance maps (1886), including clusters around both the east-side depot and the old west-side depot (built before the tracks were relocated). (DH.)

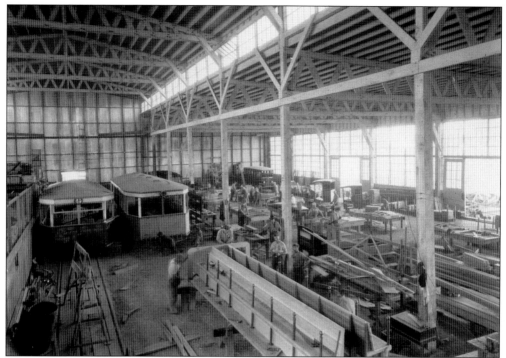

An industrial enterprise that took advantage of Woodland's woodworking tradition was the large vehicle body plant shown here. Constructed and intermittently operated between 1918 and 1923, the A. Meister Sons Company's factory at Oak Street near East Street built buses, streetcars, and electric cars. This was an era when wood rather than plastic or metal was used for the basic framework and trim for such vehicles. (GHM.)

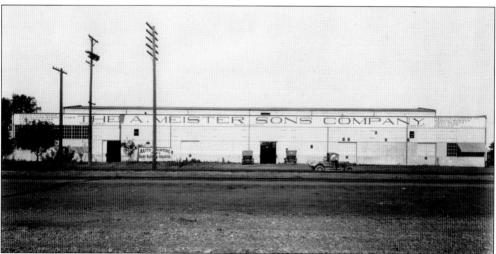

Enthusiastic Woodland boosters raised capital for and applauded the arrival of the branch plant. It belonged to a Sacramento buggy-making firm that had expanded into building motor vehicle bodies. Suddenly, in late December 1923, the seemingly thriving factory (double shifts were announced earlier in the month) received a shock. The parent firm's finances collapsed, and the Woodland plant closed forever, burning to the ground a few years later. Woodland became no Detroit. (GHM.)

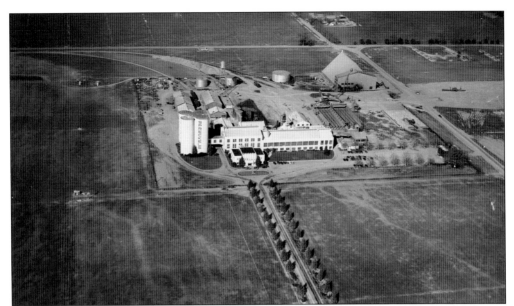

In 1937, the Spreckels Sugar Company opened a plant just north of town, which was a massive addition to the area's economic base during troubled times. The corporation did it big: bought 740 acres, constructed a distinctive office building amidst the processing units, and arranged with the Swanston stockyards to open a feedlot nearby to use beet byproduct. Spreckels was attracted to Woodland by a 35-year campaign to obtain a processing plant for the county's 40 square miles planted in sugar beets. (UCDSC.)

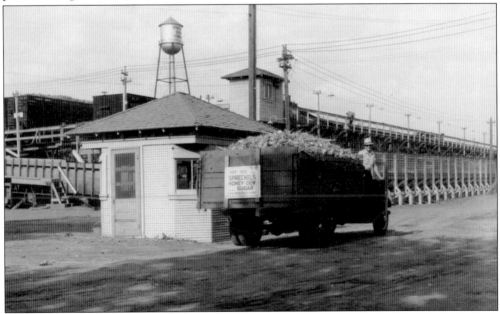

Spreckels became a major player in the life of Woodland. Its advertising was widespread, in this case seen on the back of a beet truck entering the plant. The 1937 grand opening parade and festival attracted 30,000. The county fair's beauty pageant annually crowned the Sugar Queen, receiving front-page newspaper coverage. Employment, year round or seasonal, was a common experience for many Woodlanders. Paul W. Hollingshead took this photograph.

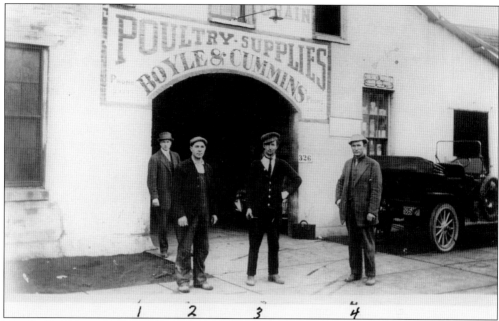

The Boyle & Cummins firm branched out in the 1920s to respond to the Northern California boom in chicken egg production. Still, Woodland became no Central Valley Petaluma. The numbers on the photograph are keyed to humorous titles written on the back: No. 1, Drummer the Boss; No. 2, Henry the Coal Buck; No. 3, Bruce Tolson the Book-Keeper; No. 4, T.D. Cummins the Chamber Maid of the Stable. (YCA.)

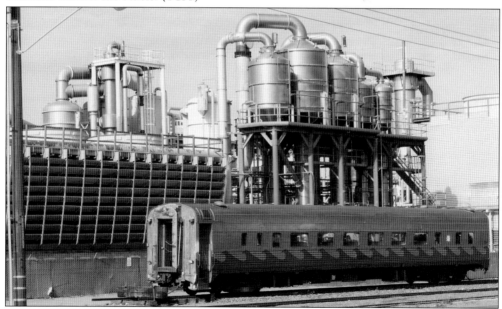

The first cannery arrived in 1902. This much later one formerly belonged to Contadina. Starting in 2002, it processed tomatoes for Pacific Coast Producers, a Lodi-based firm that has rescued a number of California's failing canneries since 1971. In the foreground is one of the brightly painted cars of the recreational Sacramento River Train Company, which runs on the old Sacramento Northern tracks. (DJD.)

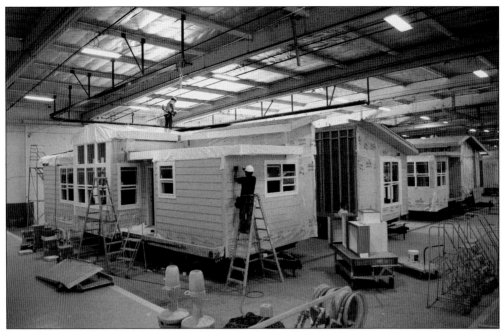

Woodland had nine mobile home manufacturers in 1974 when the chamber of commerce conducted a survey of industries in town. The cluster gave a meaning different from the usual one to the expression, "Woodland, City of Homes." Skyline is the only manufactured housing maker still operating in Woodland; its production line is shown here in 2011. (SH.)

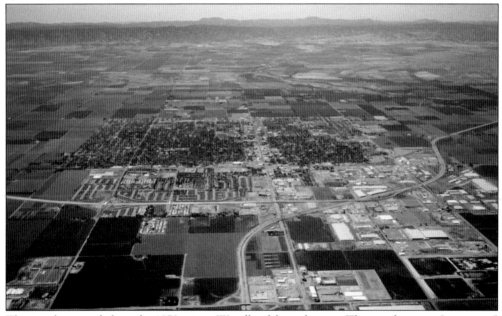

This air photograph from the 1970s views Woodland from the east. The two freeways, Interstate 5 and California 113, are in place. Mobile home manufacturers and other plants were concentrating in the expansive northeast industrial district. Woodland's golden era as a general-purpose industrial area was from 1970 to 2000; since then, manufacturing has grown less important, and warehousing and distribution have become more so. (YCA.)

Four

HOMES
INDIVIDUALISM EMBODIED

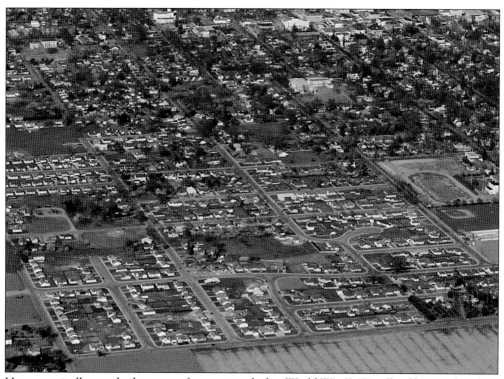

Houses typically were built one or a few at a time before World War II. Woodland has an abundant inheritance from that age, consisting of many houses with true individuality. This photograph from 1953 illustrates a new phase in homebuilding, when the scale and speed of production increased and standardized tract homes became the norm. At the lower left of the photograph is the intersection of West Street and Gibson Road. (UCDSC.)

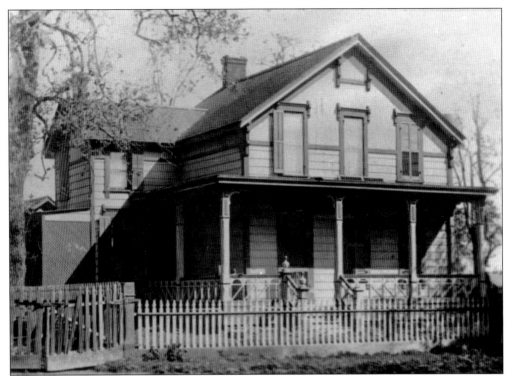

This plain farmhouse was the home of Franklin and Gertrude Freeman from 1857 until 1868. They built it close to Wyckoff's store-saloon in Yolo City. While living in the house, Franklin took seminal steps in the founding of Woodland: establishing the Woodland Post Office, finding temporary space for a courthouse, building the settlement's first brick commercial building, erecting a gristmill, and filing a town plat. This house stills stands at 1037 Court Street. (GHM.)

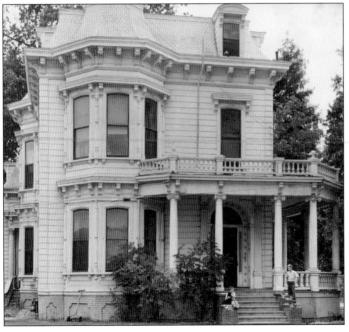

As Woodland grew and the Freemans prospered, they moved into a much fancier town house at 437 First Street, built in 1879 in the Second Empire style. The new house reflected not only the Freemans's financial success, but also the growing town's ability to support local planing mills, businesses that cut Northern California's abundant redwood into the myriad functional and decorative pieces demanded by Victorian architectural taste. This house was demolished in 1949. (GHM.)

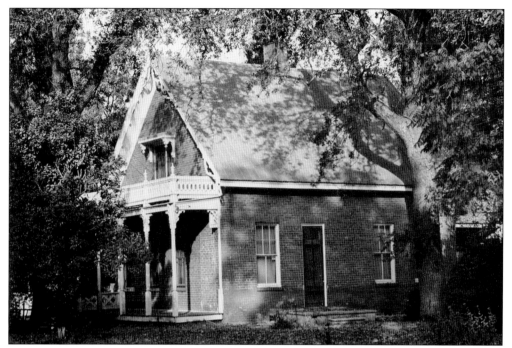

Among Woodland's oldest homes is 947 Court Street. The house was built and sold to Yolo County sheriff James P. Bullock and his wife, Mary, in 1870. The facade of a simple, gable-roofed brick box was dressed with lacy wooden bargeboards and other decorative elements. It has lost some of that decoration but still stands, as do the big oaks seen here. (GHM.)

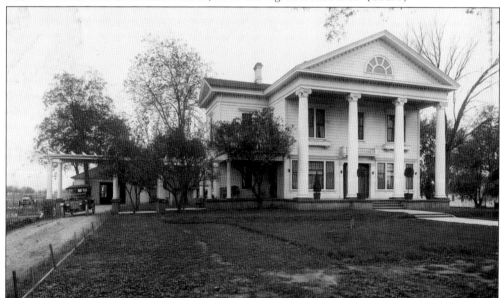

The Francis Bullard house was built around 1870 to replace a much smaller Saltbox, which in turn had replaced Bullard's first pioneer home in Yolo County, an adobe structure. Bullard's son added the Greek temple front in 1912 to the original subdued Italianate farmhouse. Under Bullard, the farm became one of Sacramento Valley's livestock show places, principally for its thoroughbred Spanish Merino sheep, which were winning prizes in Paris by 1875. (YCA.)

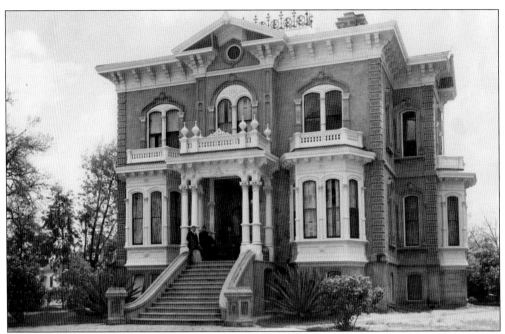

The wealth that paid for this 1873 grand Italianate mansion on Cross Street came from John D. Stephens's grain farming and stock raising in the Capay Valley west of Woodland. In 1869, he helped found the Bank of Woodland, the city's first, and he served as its president for the next 30 years. Stephens was a leader in developing local infrastructure, both rural (the Capay Irrigation Ditch) and urban (Woodland's water and gas systems). (YCA.)

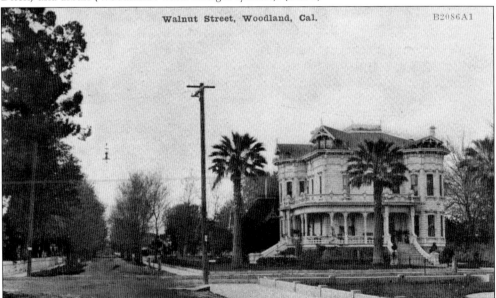

This stately home at Walnut and Main Streets belonged to A.D. Porter, who opened a wholesale and retail grocery store on Main Street in 1870. Porter became wealthy by investing profits from this successful enterprise in Woodland real estate. He strengthened Woodland as Yolo County's financial center by organizing the Bank of Yolo in 1883 and the Yolo County Savings Bank in 1891. (YCA.)

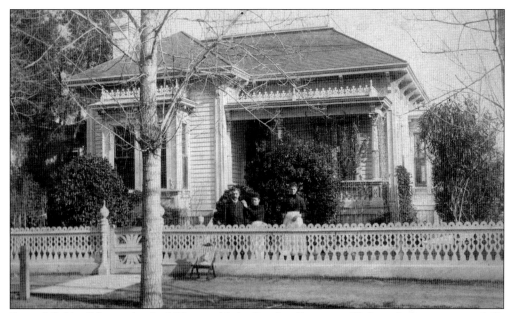

Samuel Caldwell learned to build "painted ladies" in San Francisco. He brought his carpenter skills to Woodland in 1870, where he opened the Yolo Planing Mill and built houses and institutional structures. He constructed this one-story Italianate at 547 First Street in 1882 and sold it to Theodore (later a city councilman) and Elizabeth Muegge two years later. The house has lost its iron cresting and lovely fence but survives to this day. (GHM.)

The house peeking out from behind the trees is 817 First Street, built in 1893 for Marshall DeKalb Hurst. The home of his twin brother and fellow attorney, Granville Percy Hurst, was built in the same year on the same block (at 803 First Street). G.P. Hurst was a well-known amateur astronomer with the biggest telescope in Yolo County. His daughter Vida Griggs described her childhood in this neighborhood in *A Run Around the Block*. (GHM.)

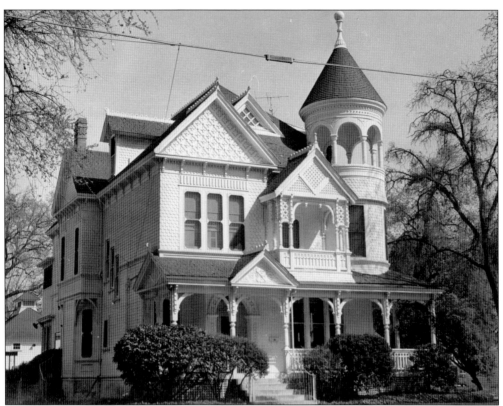

This richly gabled and elegantly turreted Queen Anne mansion at 619 College Street was built for hardware wholesaler and civic leader Marshall Diggs and his wife, Georgia, in 1892. Diggs served as mayor of Woodland and as a state senator and helped bring the University Farm (later the University of California) to nearby Davis. Later, the house belonged to David Quincy Adams, the owner of Adams Grain Company. On Christmas 1972, fire did extensive damage to the house, which was demolished. (Both, GHM.)

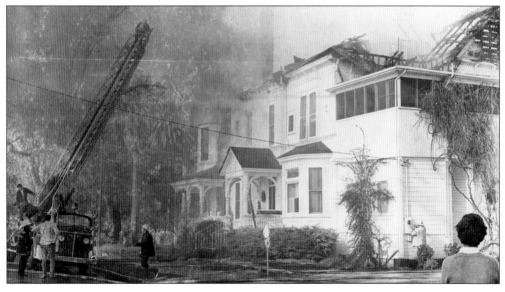

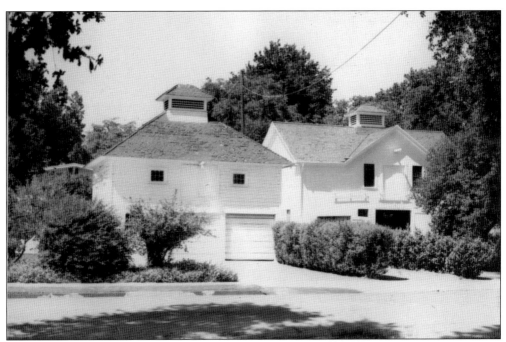

Joseph Johnson Hall, the architect of the Diggs-Adams house, spent only a few years in Woodland, leaving behind three Richardsonian Romanesque stone buildings on Main Street and two Queen Anne houses, all very fashionable. Two of these buildings are gone, so the preservation of the Diggs-Adams carriage house, incorporated into a replacement residence, is especially welcome. (GHM.)

Elegantly dressed, Carrie and Annie Blowers stand around 1910 on the porch of the Blowerses' Victorian country home, located on what became the Yolo County Fairgrounds. Their father, Russell B. Blowers, was an important and successful agricultural innovator. Annie's obituary mentions that she was "an efficient manager of the ranching interests of her father." (YCA.)

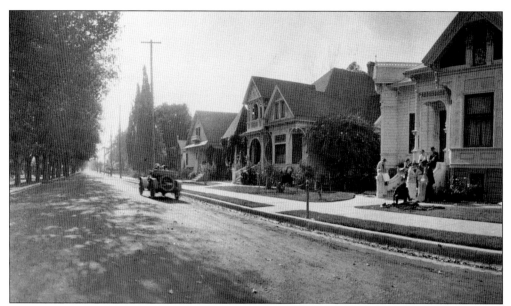

Looking southward, one can make out 632, 638, and 644 First Street, built in 1888, 1892, and 1907, respectively. Two highly decorated Queen Annes contrast with one subdued Colonial Revival, reflecting a change in architectural fashion. As early as the 1870s, city leaders started a tree-planting program in the city. The results can be seen on the left side of the picture. (GHM.)

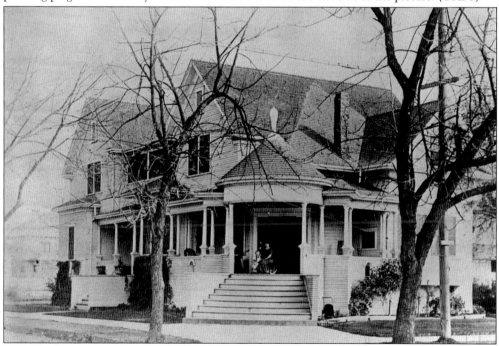

Woodland's prosperity over many decades has brought it an abundance of striking individual homes, such as this one built in 1903 for F. Kauffman, the manager of Sierra Lumber Company. The house at 803 College Street still catches the eye with its prominent porch approached by a broad flight of steps and topped by a large conical roof. The roof was raised, and the attic was turned into a full second story just four years after initial construction. (YCA.)

Sarah Laugenour Huston was active in the Christian Church (Disciples of Christ) in Woodland and helped found the local Women's Christian Temperance Union in 1883. She used her voice as founder, publisher, and editor of the *Home Alliance*, a weekly newspaper that campaigned tirelessly against alcohol and its evil effects on family life. In 1911, Woodland voters closed every saloon in town. Huston also advocated for women's suffrage and served on the Woodland City Council. (YCA.)

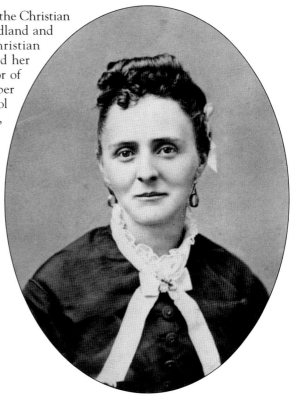

Located at the northwest corner of Main and Walnut Streets, this 1891 Shingle-style home belonged to members of two leading Woodland families, successful at both farming and commerce. Three Laugenour brothers and their wives owned it in succession, followed by two generations of the Hershey family, best known today for investing in the second Woodland Opera House. (YCA.)

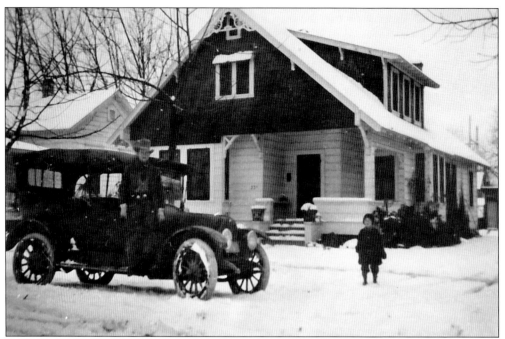

The Bungalow, typically a one-story house with a gabled roof, prominent eaves, and a large porch, was very popular in California in the early decades of the 20th century. It represented escape from the fussiness and formality of the Victorian house. Woodland has many notable examples, including this one from the Laugenour family, shown on a rare snowy day. (YCA.)

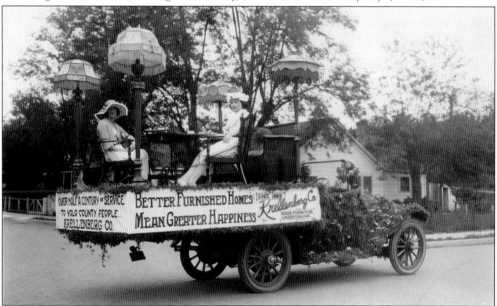

The slogan on this decorated truck, "Better furnished homes mean greater happiness," captures the essential spirit of advertising, as directed toward the domestic sphere of consumption dominated by women. Krellenberg's store on Main Street had been furnishing Woodland homes since 1869, about half a century, when this picture was taken, probably in conjunction with one of the city's floral parades. (YCA.)

Beamer's Woodland Park subdivision was an investment of the Keystone Development Company of Oakland and was designed by Berkeley-trained landscape architect Mark R. Daniels. The brick and molded-concrete Beamer arches, built in 1914, provided an elegant entrance to the small neighborhood of curving streets aimed at prosperous families. The arches were restored in 1996 as a result of volunteer efforts. (UCDSC.)

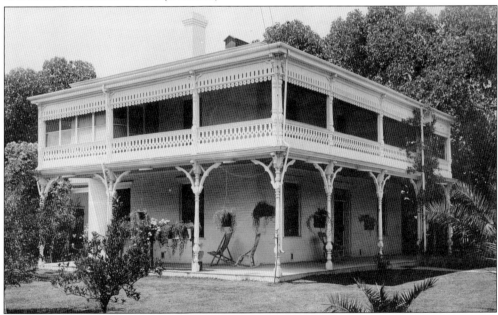

The 1860s brick house of Richard L. and Rebecca Beamer is among the oldest homes in Woodland. Monterey Colonial and Italianate details blend together in the architecture of this house. It sat on what was the 400-acre Beamer farm. Membership in the Christian Church of Woodland may have inspired Rebecca Beamer's generosity to the down-and-out, which earned her house the nickname, "Grandma Beamer's tramp hotel." After she died in 1913, the house was sold with 130 acres to the Keystone Development Company. (YCA.)

The Beamer Park subdivision took several decades to build out. As a result, it is a mix of bungalows and various period revival styles. The middle two houses are Tudor Revivals, and the rear one is Mission Revival. All three are the work of prominent designer-builder Joseph G. Motroni, an immigrant from Italy. He was the leading shaper of Woodland's residential landscape in the 1920s, 1930s, and 1940s prior to the postwar tide of tract homes. (UCDSC.)

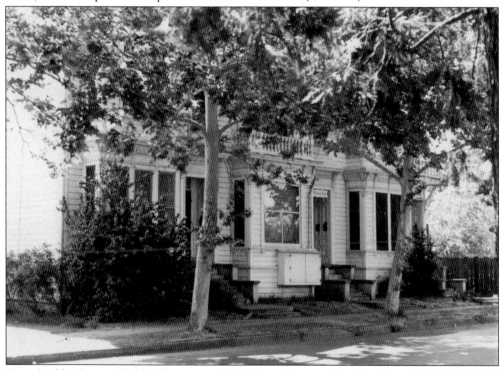

Here, builder Samuel Caldwell again included the influence of his San Francisco years in the "Triple House," located at 165-167-169 College Street in 1893. Called at the time the "Caldwell Apartments," morphologically, they are row houses. They have been further subdivided into six units. A rarity in Woodland, they stand as a reminder of the diffusion of big-city ideas to smaller towns in their hinterlands. (GHM.)

80

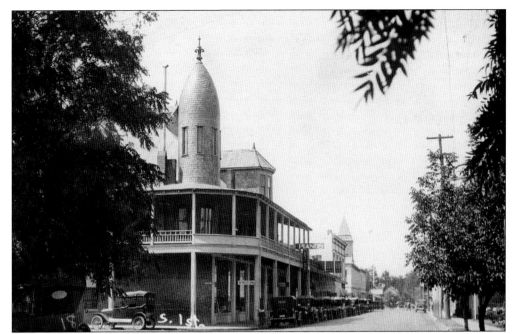

The Jackson Building at 428 First Street is Woodland's most instantly recognizable structure. Like many downtown Victorian buildings, it was designed for mixed use, in this case ground-floor retail and second-story apartments. The wraparound porch, bow-windowed dormers, slate roof, and amazing bullet-shaped tower comprise a beloved legacy built as an investment property for Dr. George Jackson in 1891. (YCA.)

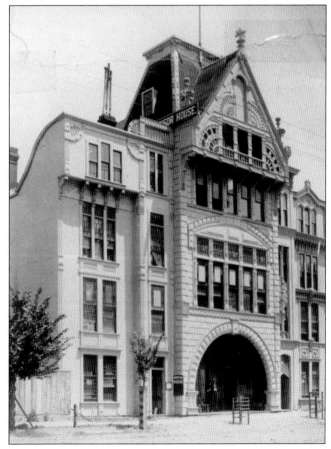

The Young Men's Christian Association in Woodland has a strong history highlighted by construction in 1887 of a four-story YMCA building that was only the second on the Pacific Coast. The building was quite fancy and proved too expensive for the "Y." It moved out within a few years. The new owner used the structure as a boardinghouse until demolition around 1917. (YCA.)

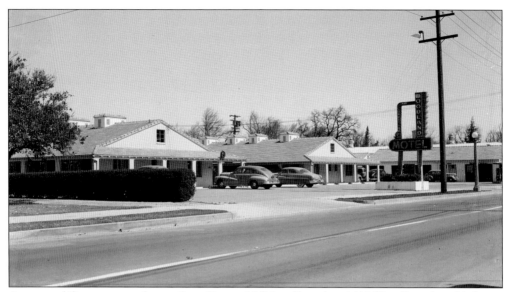

As automobility grew, travelers on State Routes 16 (Main Street) and 113 (East Street) could choose from a range of independent motor courts and motels. Later, as freeway-oriented lodging chains came to dominate, some older motels were torn down. The Woodland Motel, seen here, survived by conversion to 50 units of affordable rental housing, now called Woodland Manor. (UCDSC.)

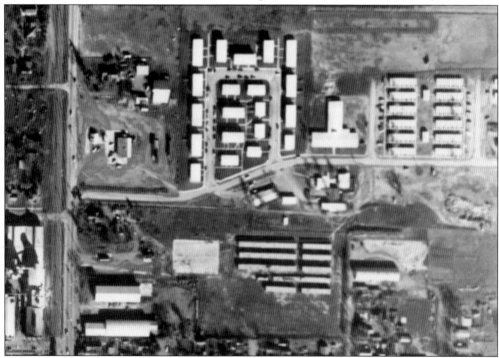

At the far right of this 1953 image are several rows of units put up in 1942 as the Woodland Farm Labor Supply Center Camp. A family got one room, without running water or sanitary facilities. In the center is Woodland's first public housing, Yolano Village, whose tenants came in part from the camp next door. This early (1952), federally funded, nonfarm, rural housing made Yolo County Housing an innovative agency—a role it plays today in the field of sustainability. (YCA.)

Five

COMMUNITY
SHARED PLACES

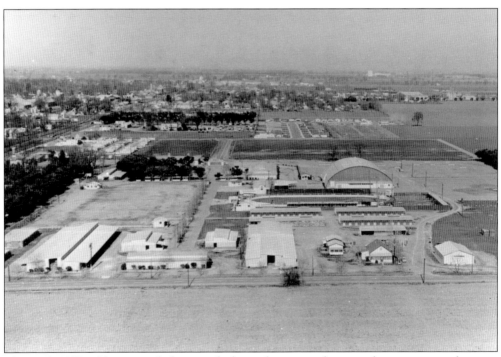

This early 1950s oblique aerial photograph shows the county fairgrounds in its postwar location on the former Blowers Ranch on East Street north of Gibson Road. The fair remains popular, and not just because it is one of the few remaining in California with free admission. Devoted fairgoers come from all of Woodland's social and economic groups to share individual and community accomplishments, including those in agriculture. (YCA.)

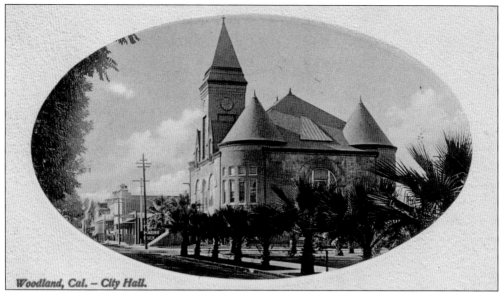

Woodland, Cal. – City Hall.

The building that housed Woodland's first city hall and fire station was a statement of the town's self-confidence. A heavy, slate-roofed, towered edifice with Romanesque and Medieval styling was built in 1892 to a design by San Francisco architects. Perhaps partly due to earthquake damage, the building developed structural problems. Deemed unsafe in 1931, it was pulled down. (YCA.)

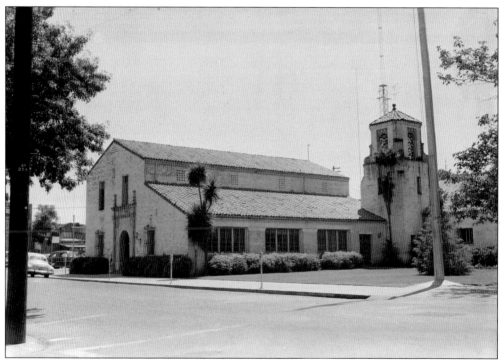

The 1932 city fire station and jail and the adjacent 1936 city hall are in a Mission Revival style, which gives Woodland another touch of that popular Santa Barbara look so favored by Californians in the early decades of the 20th century. When New Deal funding paid for about half of city hall's cost, perhaps it was a reward for a county that voted strongly for FDR. (UCDSC.)

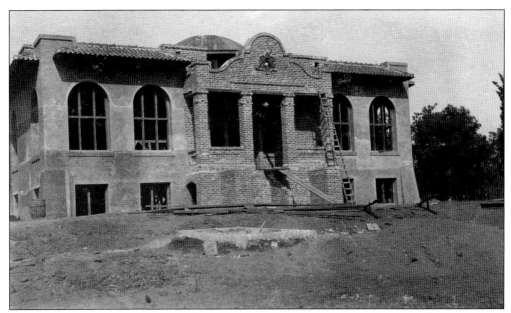

Women organized the Woodland Library Association in 1874. In 1891, the city took over support, but the library remained in rented rooms. In 1903, the Women's Improvement Club (WIC) put together a winning package for a library building: funds given by Andrew Carnegie, a site donated by Capay Land and Stock Company, and a commitment by the city to maintain the building. The cornerstone was laid in June 1904. (GHM.)

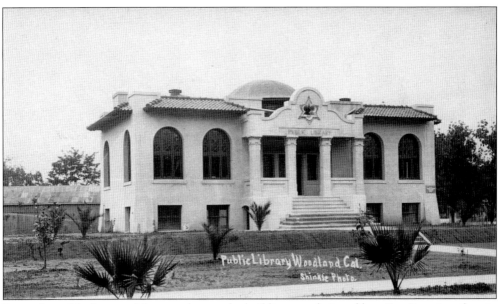

Located one block west of the courthouse, the building was designed by a San Francisco firm in the Mission Revival style. Completed in 1905, it was enlarged in 1915, 1927–1929, and 1985–1988. The baby palms planted in 1905 are today sturdy giants. Palms were strongly advocated by WIC, based on arguments of the California Promotion Committee published in the local paper that subtropical evergreens should be planted to impress visitors from colder climes. (GHM.)

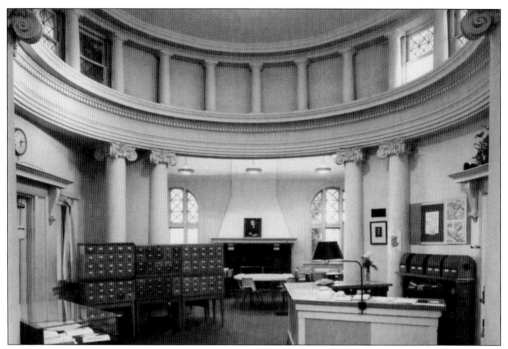

A classical rotunda, such as this, was a characteristic feature of Carnegie libraries. It symbolizes the achievements of classical civilization and the role of libraries in preserving learning. Many of the library's wood furnishings were made from oak in a Mission style, which was popular at the time and hearkened back to California's era of Spanish settlement, another link to the Mediterranean world. (YCA.)

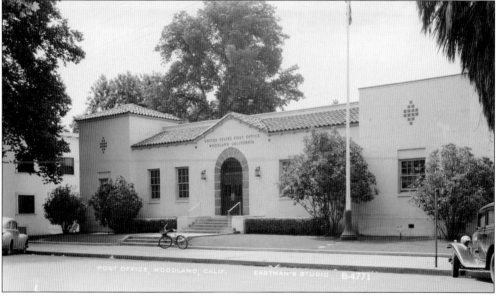

Works Progress Administration (WPA) funding from the federal government in 1935 gave Woodland a new post office constructed in Spanish Colonial Revival style. East of city hall and south of the Yolo County Courthouse, the post office further solidified Woodland's civic center. Interior murals that are heroic realist depictions of agricultural life are of the same era. (UCDSC.)

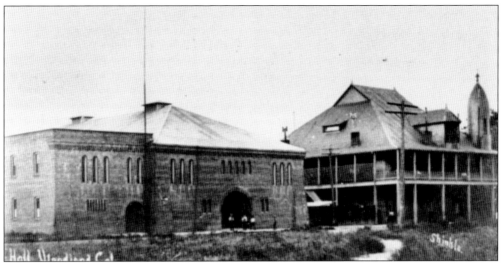

On the left is the Armory Hall Building of 1895, a home on Bush Street for the National Guard unit first formed in 1881. A large venue, it was the scene of thousands of community events. It sometimes hosted fair exhibits and was a movie theater in the 1930s. Once owned by Bank of Yolo, it was taken over by the American Legion after World War I; they built a replacement legion hall in 1962. (GHM.)

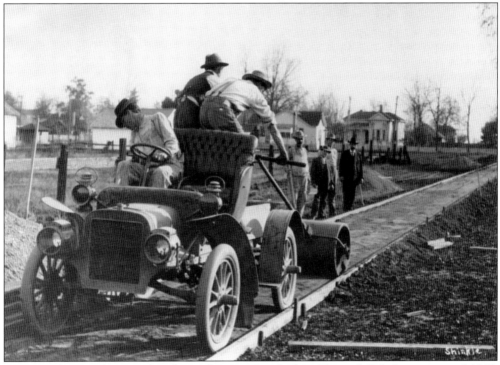

These workers are laying sidewalks in the new City Park at Elm and Oak Streets around 1909. The photograph shows another aspect of Woodland's love affair with the automobile, in this case using it as a work machine. The Women's Improvement Club bought the entire block for this first of a network of parks and recreation facilities. Woodland was a bit late in getting parks; Chico and Marysville already had them. (YCA.)

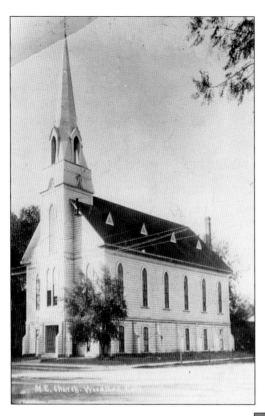

This Victorian building was erected about 1885 for the Methodist Episcopal (ME) Church at North and Second Streets, facing the courthouse square. It lasted until 1924 when the present complex was built. In 1939, this congregation absorbed the ME South congregation that had a similar building. The roofline is 30 feet above the ground, and the steeple rises to 50 feet. (YCA.)

This 1912 structure was the fourth Holy Rosary Catholic Church in Woodland. The current church was built in 1949 to replace the beautiful but structurally unsound building depicted here. The 1912 church was a bit of an architectural marvel, with granite-faced walls and a large statue of Queen of the Rosary on the roof parapet above the front entrance facing Main Street. (YCA.)

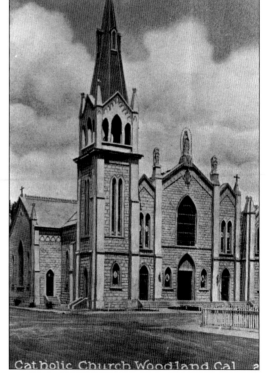

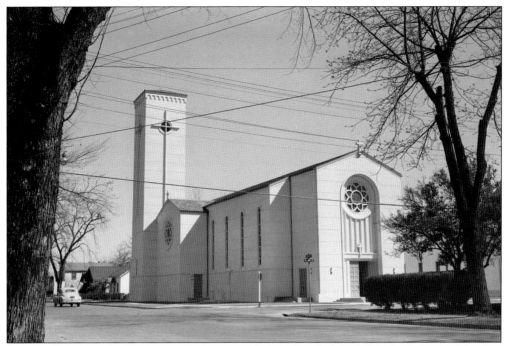

In use today is the less ornate Holy Rosary Catholic Church, located on a site just north of its predecessor. The 108-foot bell tower makes it a landmark. Architect Harry Devine, who was honored by Pope Pius XII, designed other major Catholic churches in the region as well as Christian Brothers High School in Sacramento. (UCDSC.)

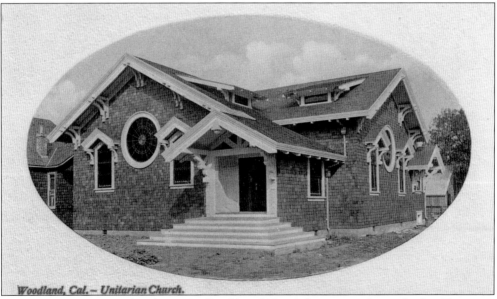

Woodland, Cal. — Unitarian Church.

In 1910, the Unitarian Church in Woodland hired Napa's foremost architect, Luther Turton, to design a new building for them at 417 Lincoln Avenue. It was the embodiment of the California Craftsman style, with a shingled exterior, large gabled roofs, and prominent bracketed eaves. The windows were the building's most churchly feature. Its exterior has been greatly remodeled, but the interior retains some Craftsman feel. It serves as the Lions' clubhouse. (YCA.)

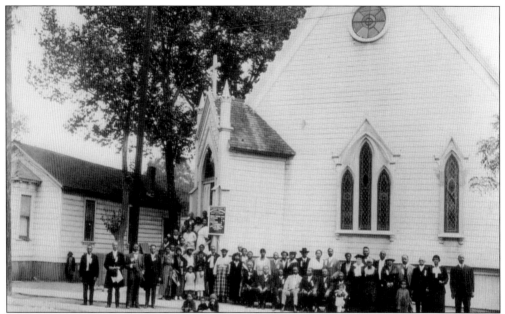

Designed in 1887 by William Henry Carson, an important Woodland architect and designer of the Byrns Hotel, this building at 435 Second Street began life as an Episcopal church. The Second Baptist Church, founded in 1894, purchased it for $10 in 1909, and it was the congregation's home until it burned in 1971. Today, the site has a replacement church building occupied by the Greater Second Baptist Church. (YCA.)

Shown in 1926, the Christian Church was the sponsor of Hesperian College, and those buildings, along with a similarly scaled Baptist church, dominated the area of Lincoln Avenue and College, Bush, and First Streets. A truly massive structure with Gothic detailing, the Christian Church spire rose to 75 feet. In 1949, the Christian Church built a Mission Revival church at the site on the southeast corner of Lincoln Avenue and College Street. (GHM.)

In Woodland since 1871, Saint Luke's Episcopal moved in 1912 into this Medieval Revival gem. William Hays, who designed buildings at University of California, Berkeley, and University of California, Davis, gave the corner of Lincoln Avenue and Second Street a Gothic-inspired design and Arts-and-Crafts spirit. Windows by Tiffany were added a decade later. (UCDSC.)

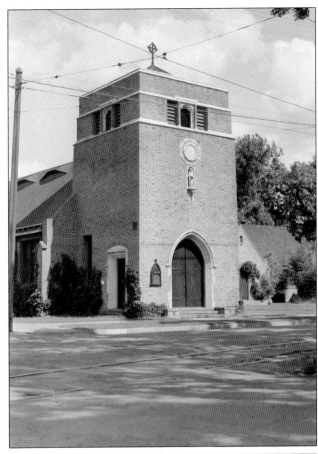

While this structure is often referred to as "the first school," there was an earlier one, built in 1853 in what became Beamer Park. This one was built in 1856 near present-day Lincoln Avenue and the railroad. The Sons of Temperance, the first fraternal organization in town, with the help of some local Masons, added the second story to the school to create space for its meetings. (GHM.)

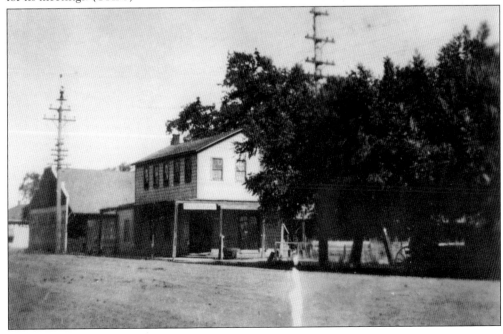

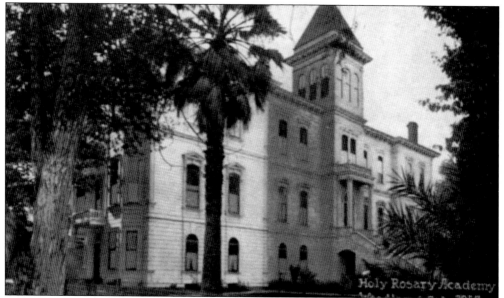

Holy Rosary Academy, a boarding school, was opened in 1874. It became a renowned educational institution drawing students from throughout the West. The Italianate three-story building with its veranda and central tower was designed by prominent San Francisco architect Bryan J. Clinch. Demolished in 1956 after a fire, it was replaced by the Woodland Shopping Center, located west of Cleveland Street. (BW.)

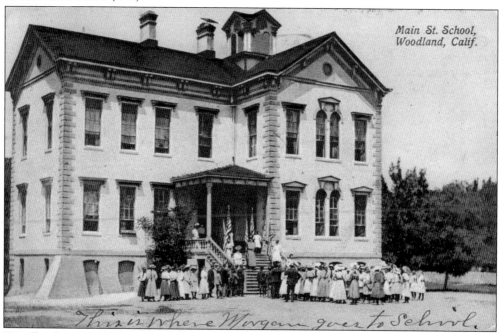

Woodland experienced a wave of public and private school building in the 1880s that produced impressive results. Built in 1887 at Walnut and North Streets, this school's eclectic design has Italianate elements. Called the Woodland Grammar School, it was also known as the Walnut Street School. Woodland High School spent its first year here (1895–1896). The photograph is from 1899. (GHM.)

Amazingly, the four-story tall Hesperian College building dates to 1861 when Woodland still lacked a gridded street plan. A primary and secondary school curriculum offered vocational and college preparatory classes. Sponsorship was by the nearby Christian Church (Disciples of Christ). The 1895 armory replaced the building eight years after the school moved to a less commercial part of Woodland. (YCA.)

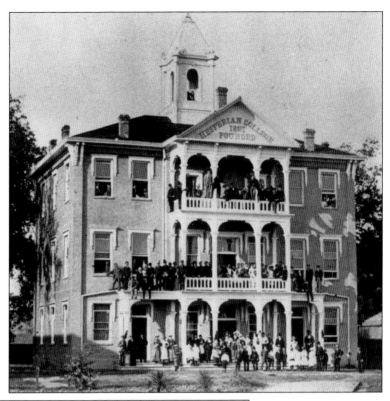

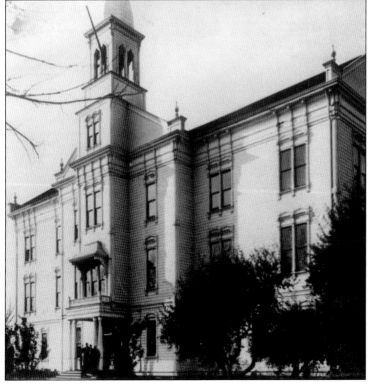

Hesperian College was relocated to College Street (renamed at that time) in 1887. When that school left for Berkeley in 1896, Hesperian's campus became Woodland's first public high school. The high school received a classy new building in 1913 and remained at Hays and College Streets until 1971. Douglas Junior High now occupies the site. (GHM.)

Miss Lola Bray is shown on the right overlooking her 39 third-grade students at Oak Street School in 1902. The 1889 building—designed by William Curson, who also did Woodland's library and Odd Fellows Hall—was replaced in 1916 with Elm Street School, located at the intersection of Elm and Oak Streets. Hundreds, perhaps thousands, of similar photographs were taken on these and other Woodland school steps through the years. (GHM.)

Dingle School, a handsome product of architect William Weeks in 1924, shows off its nine handsome teachers of the same year. The location is the same as that of Elm Street School, which burned down. Charles Edward Dingle (standing, second from left), the namesake of the school, was a newly retired senior citizen in 1924 and was honored for his 41 years as an educator. (GHM.)

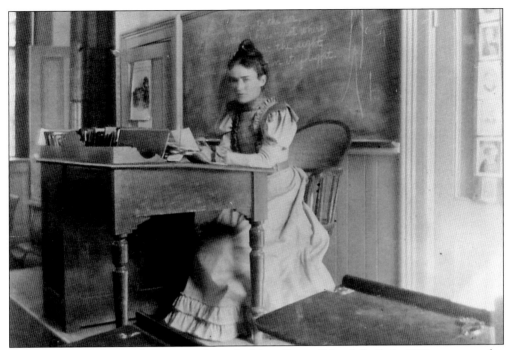

Miss Lulu A. Shelton is shown at work in the Main Street School (built in 1872 at present-day Freeman Park). Her blackboard contains a four-line poem, "The Sparrow and the Song." In addition to being an educator, Shelton was active in the Native Daughters of the Golden West. (YCA.)

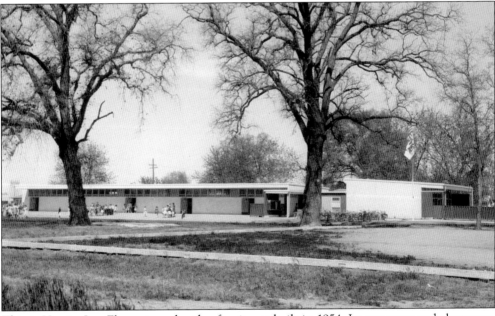

This is Harriet Lee Elementary shortly after it was built in 1954. Its one story and classrooms opening directly outdoors were typical of California schools of that era. The oaks, still present today, are worthy of "Woodland, City of Trees." In 1966, the school was modified into Lee Middle School. Harriet Stoddard Lee graduated from Hesperian College and was the Yolo County superintendent of schools. (GHM.)

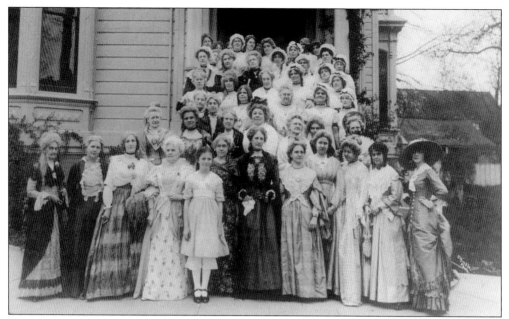

In 1886, five prominent women founded the Woodland Shakespeare Club, now recognized as California's second-oldest book club. Shakespeare clubs were a way for women to combine self-improvement with community improvement. By 1900, there were 500 such clubs across America. In this 1914 gathering at the home of Mabel Harlan on First Street, there were many representatives of pioneer Woodland families, including Blowers, Coil, Freeman, Hecke, Hershey, Hoppin, and Reith. The club continues today. (YCA.)

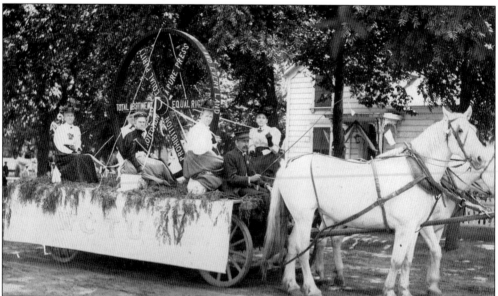

The Women's Christian Temperance Union (WCTU) was the largest women's organization in the United States by the 1880s. Its national president came to Woodland in 1883 to help organize a chapter. This float displays WCTU core goals: abstinence, prohibition, purity, and equal rights for women. The Woodland WCTU was active and successful, using the women's right to vote, approved by California voters in 1911, to shut down all local saloons that same year. (YCA.)

Emily Hoppin, married to a forty-niner who became a Woodland farmer, decided to adopt her husband's habit of reading the *Congressional Record*. It stimulated her interest in government and politics, and she became a leader in the temperance and women's suffrage movements locally and statewide. Women won the right to vote in California in 1911, and 400 women turned out to register to vote in Woodland on the first day they could. (YCA.)

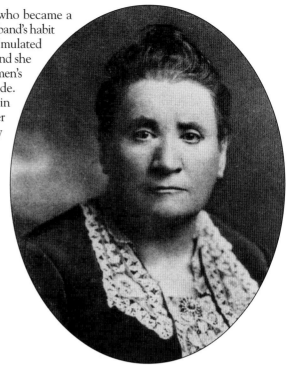

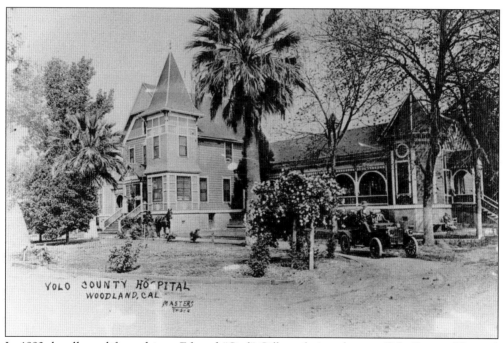

In 1892, locally prolific architect Edward "Carl" Gilbert designed a new Yolo County Hospital west of town (now the northwest corner of Cottonwood and Beamer Streets), replacing the 1863 public hospital at 121 First Street. A pleasant, arched veranda graced the patient wings in this public facility. One end turret provided rooms for mentally ill patients. (GHM.)

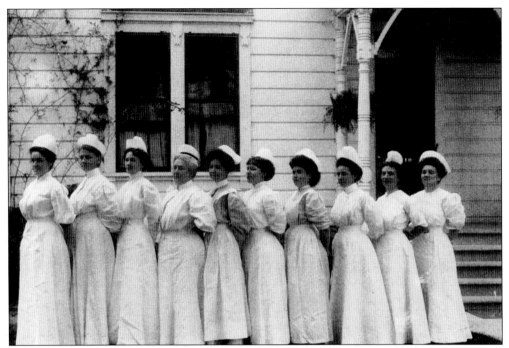

Hospital-trained nurse Kathleen McConnell founded Woodland Sanitarium, the city's first private hospital, in 1905. In a former house at 110 College Street, she provided sterile conditions for surgery, which previously was done on kitchen tables in private homes. When McConnell married and retired from nursing, four doctors who had practiced at the 110 College Street site built a new sanitarium at Third and Cross Streets. (YCA.)

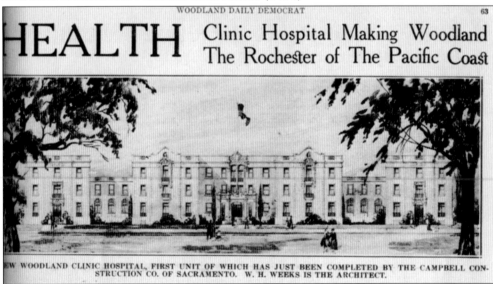

HEALTH Clinic Hospital Making Woodland The Rochester of The Pacific Coast

EW WOODLAND CLINIC HOSPITAL, FIRST UNIT OF WHICH HAS JUST BEEN COMPLETED BY THE CAMPBELL CONSTRUCTION CO. OF SACRAMENTO. W. H. WEEKS IS THE ARCHITECT.

The group practice of the doctors who built the new sanitarium was innovative and similar to that pioneered by the Mayo Clinic in Rochester, Minnesota. Dr. Charles Mayo came to Woodland several times to consult on the expansion of the sanitarium facility in 1920. By the mid-1920s, local boosters were hoping that the highly regarded and economically significant clinic and hospital would make Woodland "the Rochester of the Pacific Coast." (WDD.)

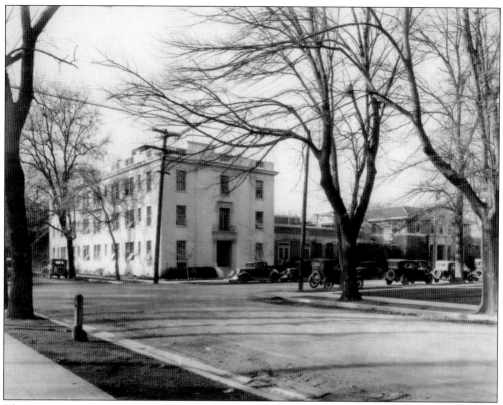

The new 1911 sanitarium in the Mission Revival style had a residential feel and included pleasant outdoor space. Attention to such aspects of patient care continued in future decades, as the sanitarium, renamed the Woodland Clinic Hospital in the 1930s, evolved according to a master plan developed by William Henry Weeks. The three-story hospital portion of the complex was erected in 1928. (GHM.)

The photograph above shows an unidentified assembly at the Woodland Armory in the early 20th century. At that time, the prosperous city of Woodland, with its rail connections and many hotels, was an important location for large gatherings of all kinds. Chautauqua assemblies, bringing a mix of education and entertainment to the local area, were an annual event in Woodland into the 1920s. (GHM.)

At the beginning of the 20th century, the Independent Order of Odd Fellows was the largest fraternal organization in the United States, with its membership exceeding that of even the Masons. In October 1909, Woodland played host to the IOOF Grand Encampment. The gateway arch with its All-Seeing Eye, located on Main Street adjacent to the Odd Fellows Building, welcomed attendees to the event. (YCA.)

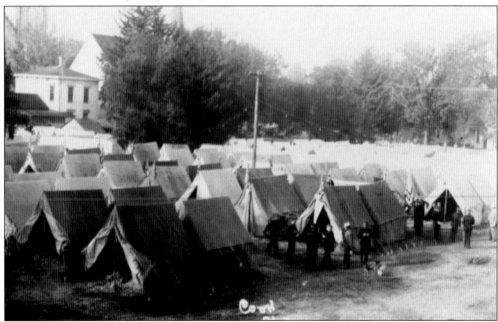

These tents, erected south of Main Street near present-day Bush Street, housed attendees at Woodland's 1909 Odd Fellows Grand Encampment. In addition to being a gathering of Odd Fellow members, "Encampment" referred to a branch of the organization that was open to members holding a rank of third degree or higher. (YCA.)

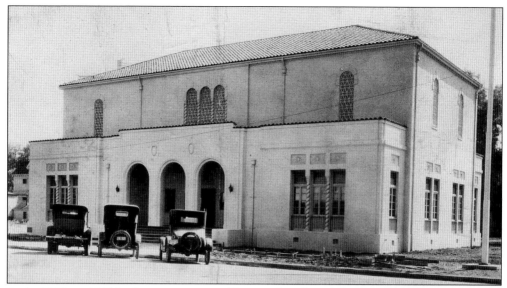

In the 1920s and 1930s, the construction of freestanding fraternal meeting halls was common in Central Valley towns. In Woodland, the most impressive of these is the Woodland Elks Lodge on Bush Street. While Elks Lodge No. 1299 was founded in 1913, the building for the lodge was not erected until 1926. Designed by William Henry Weeks, its Mediterranean Revival style includes Moorish elements. A banquet hall was added to the left side of the building at a later date. (GHM.)

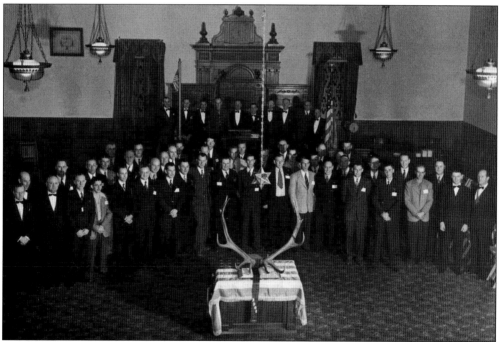

The grand meeting hall on the second floor of the Elks Lodge displays interior appointments every bit as elegant as its exterior. High ceilings, hanging chandeliers, and elaborately carved wood trim contribute to the formality and ceremonial atmosphere of lodge events. The ground floor contains offices and an elegant wood-trimmed bar. (GHM.)

James W. Monroe had not been Yolo County sheriff long when he rode horseback as grand marshal of the 1912 Fourth of July parade in Woodland. Monroe served as sheriff until 1939, after which his son Forrest served until 1971. The current sheriff's facility and jail, the Monroe Detention Center, is named for the two of them. Also pictured is Elinore Early of Davis. (YCA.)

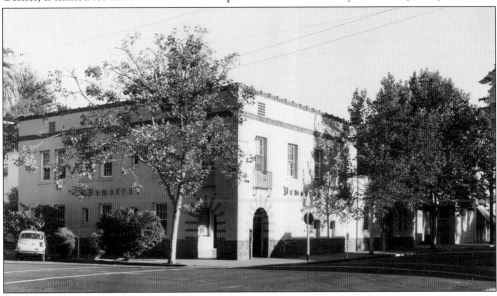

The *Woodland Daily Democrat* occupied this building at 702 Court Street, designed by Sacramento architects Dean & Dean, from 1925 to 1987. This location across from the courthouse symbolized the importance of a local free press in a democracy. Published under several names since 1864, the *Democrat* has been both documentarian of and player in the history of Woodland. The building pictured has been remodeled and now houses the Yolo County District Attorney's Office. (YCA.)

Six

RECREATION
LEISURE INDOORS AND OUT

Yolo County's three largest towns had racetracks before 1880. Woodland's first big track was at today's Brown's Corner. This 1915 topographic map shows the 1891 Woodland Racetrack just northeast of West and Kentucky Streets—a street named for the Derby. It had popular races, grandstand seating, and a record of fast times by local horses. Horseracing and then bicycle racing at this venue were major parts of early fairs, starting in 1893. (UCD.)

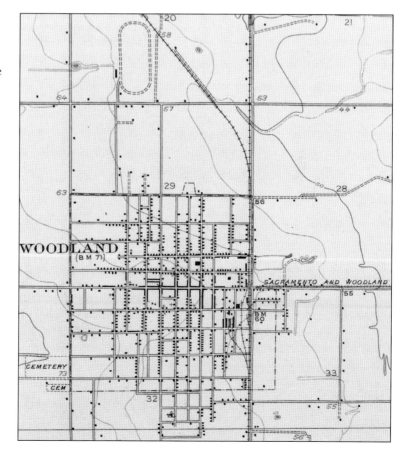

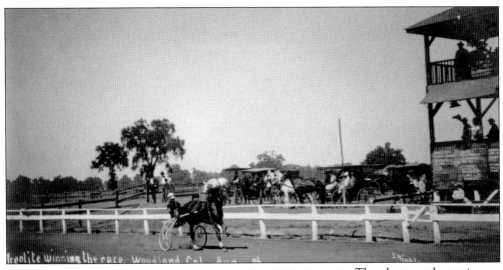

Areolite winning the race. Woodland, Cal. Aug. ...

The photograph says it is 1906, and Areolite is winning the harness race. The officials' stand is to the right. Highlights of Woodland Racetrack history came in 1911 when a local horse set a world record and in 1914 when another pacer set a Pacific Coast record in the mile. The track thrived and was home to the county fair until World War II, after which car racing rose in popularity. (GHM.)

Woodland resident Ted Jaques is seen in 1950 with a bicycle owned in the 1890s by businessman A.D. Porter. The city was bicycle crazy at that time. Shops opened for bike sales and repair. Women joined men and children in the liberating mobility of safe riding. Clubs organized rallies. Fairs had as many bike races as horse races. The Women's Improvement Club agitated for paving to encourage riding. In 1910, Foy's Bikes opened and is still in business. (YCA.)

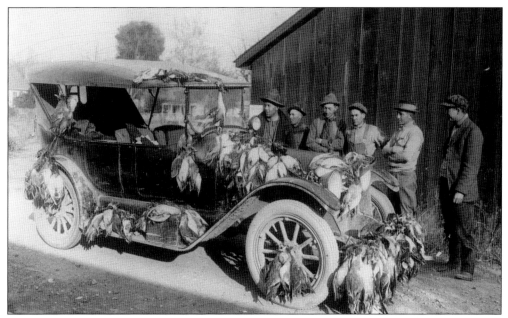

Members of this 1914 duck-hunting party show their take from a day of shooting in the tules. Substantial marshy wetlands begin just a few miles east of Woodland, part of a globally significant migratory flyway. Professionally led hunting businesses brought shooters from around the state. Adjacent is the Sacramento River with its tributaries, which play host to fishing, a major recreation and a boost to the economy. (YCA.)

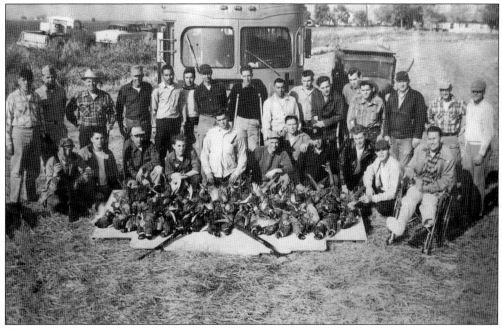

Pheasant hunting, even though the bird is not a native, once was a big recreational use of the countryside around Woodland. Here is a hunting party of veterans. Deer hunting takes place in the hilly western part of Woodland's hinterland. Today, wild turkeys are becoming abundant, but they will not fill Woodland's motel rooms with hunters! (YCA.)

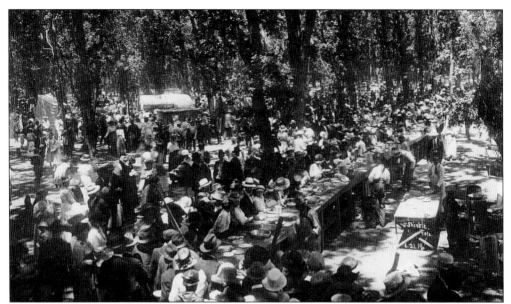

Picnics were a Yolo County tradition once so strong that the *Woodland Daily Democrat* published a calendar of them. Nelson's Grove, a 10-acre natural oak grove north of Woodland, is depicted here at the mother of all picnics. In June 1919, the "14 Counties Picnic" drew 15,000 people giving thanks for rural prosperity. Often picnics included dances, and Nelson's Grove gained a big dance floor in 1902, making it even more attractive. Today, the grounds are owned by the YMCA. (WYMCA.)

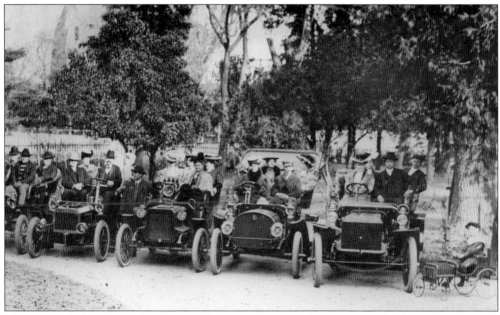

This undated photograph features mostly pre-1910 cars; only one is not the obsolete right-hand drive. This group displays the local wealth that made recreational driving a possibility for many Woodlanders. Furs and fancy hats abound. In the lower right is a young boy astride his metal model of mom and dad's big car. Even if they are just gathering in the church parking lot to show off, many are reminded of the joy of Toad's Wild Ride. (YCA.)

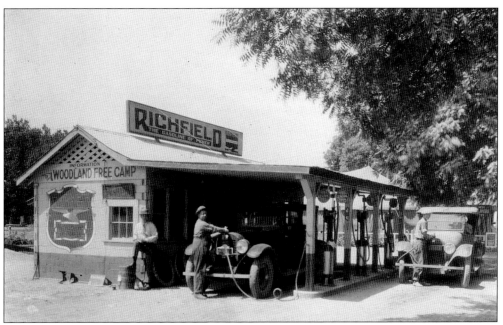

In 1923, Woodlanders arranged for a square block south of East Main Street to serve tourists as the "Woodland Free Camp." This Richfield gas station on East Street gave up some of its advertising space to inform motorists of Woodland's hospitality toward the recreational traveler. (YCA.)

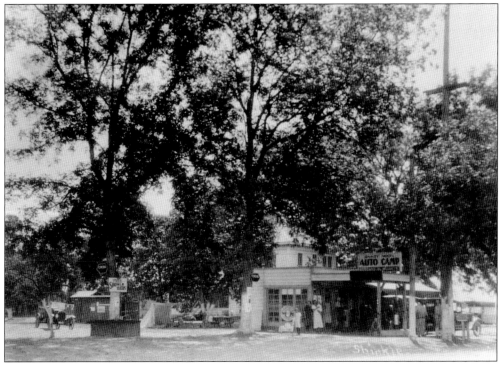

Motels were still a work in progress in the 1920s when the Shady Nook Auto Camp was opened at the southeast corner of East and Main Streets. The sign offers free showers, probably a loss leader for an enterprise that had gasoline sales and car service as its primary business. (YCA.)

This truck was a moving billboard for National Theater on Main Street. Woodland was a regional entertainment provider, drawing many movie patrons from out of town. This particular vehicle was pressed into service when candidate Franklin Roosevelt made a brief visit to Woodland on his presidential campaign in October 1932. The decision to stop at the depot was last minute, so the truck was used to turn out a crowd on short notice. (YCA.)

The 1910 Woodland High School rugby team won its league championship. At that time, rugby and football had more in common, and California was a hotbed for rugby. Young Woodland farmer Colby "Babe" Slater captained the gold-winning American rugby team in the 1924 Paris Olympics. That victory over France's "greatest rugby team in history" was one of the biggest sports upsets ever. (YCA.)

Woodland is a town serious about youth and adult sports. Here, the Woodland High School track and field team stands in front of the nearly new 1913 high school, designed by William Weeks. In addition to schools, the city of Woodland, various leagues, and service clubs have contributed to facilities for sports and recreation. (GHM.)

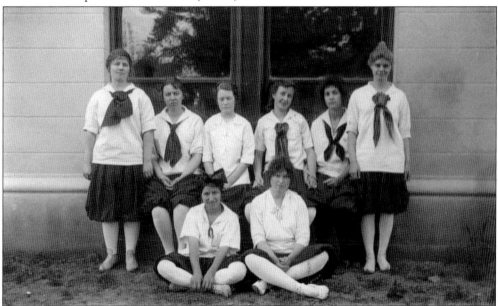

Members of the 1916 WHS girls' basketball team pose outside their school. Woodland has a long history of women participating in sports. The *Woodland Daily Democrat* has been a strong advocate for women's equality in many spheres. For 26 years, "Boss" Edward E. Leaky ran front-page stories on progressive women and their issues, including Woodlander Hazel Bess Laugenour when she became the first woman to swim the Golden Gate in 1911. (YCA.)

Woodland gave a parade in 1994 for its 13-year-old Babe Ruth Baseball League champions of the world. They won their World Series in Concord, New Hampshire, but much of their play was at Woodland's venerable Clark Field. Host of the Babe Ruth League World Series in 1964, Clark Field has been home to youth baseball since 1955. It is at Beamer Street near West Street. (YCA.)

The newly formed Roy Hobbs League team from Woodland won the World Series of Men's Senior (over 40) Baseball League in 1988. The photograph is from the Arizona tournament site, but the team practiced for a month beforehand at Clark Field. They provided the skills needed to renovate Lee Junior High's ball field into a serious home for Roy Hobbs 22 years ago. (RH.)

110

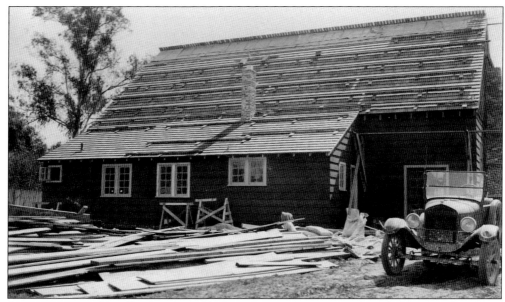

Scouting came to Woodland in the 1920s. In 1932, H.J. "Doc" Camp, an ardent backer of scouting, led a drive to build a Boy Scout Cabin. The rustic structure shown under construction that year was built with the help of donated materials and volunteer labor. Located on Lincoln Avenue just east of College Street, it is still in use today. (WBS.)

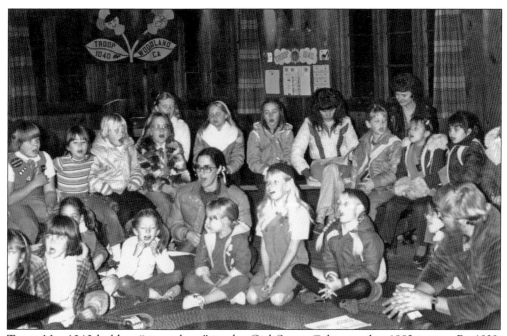

Troop No. 1040 holds a "sing-a-long" in the Girl Scout Cabin in this 1982 image. By 1939, Woodland's four Girl Scout troops had outgrown their meeting place, St. Luke's Guild Hall. Nearly $6,000 was raised, city land at 430 Grand Avenue was leased for $1 a year, and the cabin was built by workers hired via the National Youth Association, a New Deal agency. (GSC.)

In 1947, voters passed a bond issue for a Woodland Municipal Pool and four other projects; the pool was completed shortly thereafter. On Elm Street, it shares recreation space with Southland Park and the YMCA. Woodland's system of parks and recreational facilities has been a source of pride, having been given help beginning in 1902 by the Women's Improvement Club, who funded City Park at Elm and Walnut Streets in 1909. (UCDSC.)

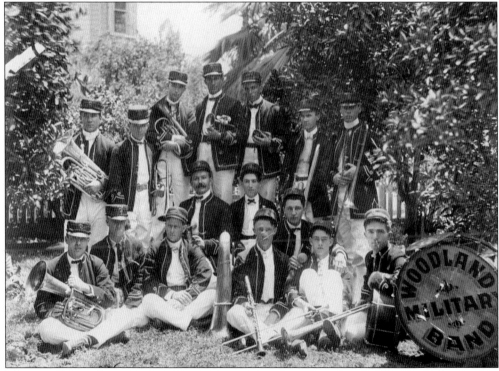

Many small towns have a rich tradition of concerts and marching bands. Woodland's bands often show up in photographs of parades and events that involved greeting or hosting dignitaries. Shown here in 1901, the Woodland Military Band was led by trombonist Kier Snavely (first row, second from right). Snavely's musical family owned the Woodland Winery. (GHM.)

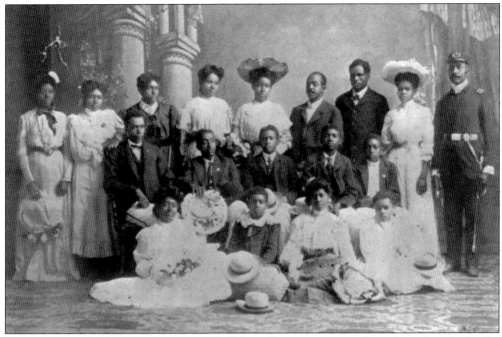

On June 1, 1905, a light, comic opera, *The Merry Company*, was performed as a benefit for the Second Christian Church. It did not sell out the house, but the performers brought down the house. The *Democrat* described the performance as "a very enjoyable entertainment at the opera house on Thursday." The review was front page, above the fold, and with the day's largest headline. (YCA.)

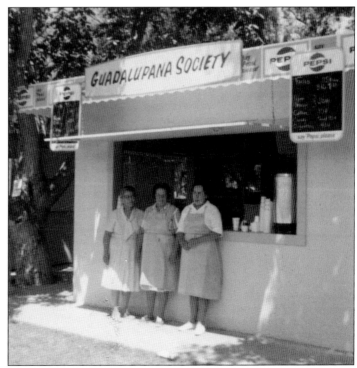

Lupe Tafoya (on the left) and Toya Sanchez (on the right) stand in front of the Guadalupana Society taco stand at the Yolo County Fair in August 1967. The Guadalupana Society is a social organization affiliated with Holy Rosary Catholic Church. Ramon and Lupe Tafoya founded the society in 1951, and later, Otilia Contreras, after retiring from La Villa Café, played a major role. For many visitors to the Yolo County Fair, the tacos have been a good reason to return. (Courtesy of Helena Ochoa.)

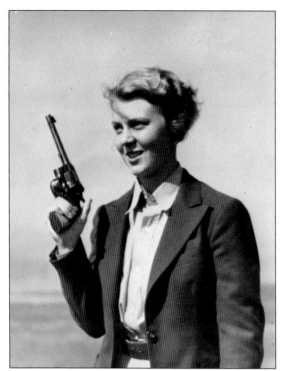

Gloria Jacobs Norton was a pistol-shooting phenomenon. In eighth grade, she won the California Women's Championship. In 1940, at age 17, she won the world championship. She accumulated 285 medals, trophies, and cups for marksmanship. She trained by shooting rats at a dump near Lemen and Cannery Streets. She was "the miss who never misses." (YCA.)

This sign thanks Woodlanders for a successful 1960 fundraising campaign. It enabled construction of a YMCA recreation center at College Street north of Gibson Street. The modern design by Robert Crippen could scarcely have differed more from the Victorian 1887 Woodland "Y" building that was located downtown. (WYMCA.)

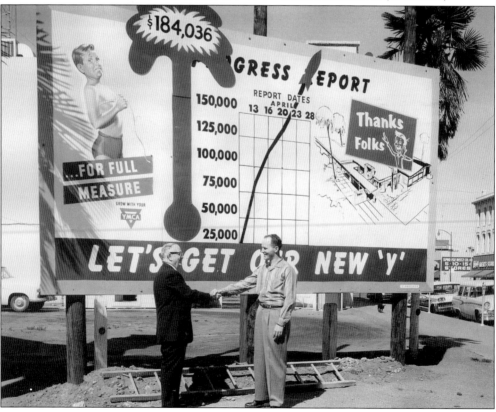

Seven

PRESERVATION
VALUING HISTORY

This map displays the distribution of 315 historic residential properties featured in the walking tour guide *Explore Historic Woodland*. First produced in 1975, the 2007 edition is a 296-page treasure trove of information on Main Street, Dead Cat Alley, and eight classic neighborhoods. In early decades, most elite houses were built south of Main Street; this pattern was changed somewhat by the development of Beamer Park in the north after 1913. On all tours, the diversity and quality of Woodland's older housing stock are apparent. (FPD.)

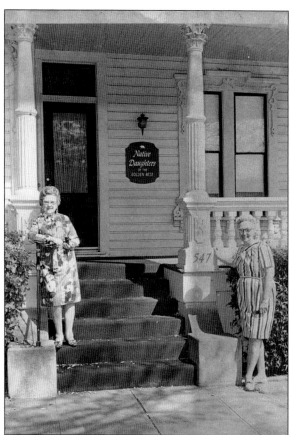

The Woodland Parlor of the Native Daughters of the Golden West (NDGW) had its clubhouse in the Muegge house at 547 First Street when this picture was taken in 1971. Alice Torrence (left) and Mrs. Ted Jacques flanked the entrance. This property was one of six homes opened for a Victorian home tour in that year, organized by the Yolo County Historical Society. The Woodland NDGW had been honoring local California pioneers and inviting them to tell their stories since the late 19th century. (GHM.)

Woodland has a good record when it comes to preserving historic vehicles. Antique fire equipment has long been a favored entry in Woodland parades, especially the department's first engine, an 1874 Clapp & Jones. In 2009, volunteers opened a fire museum in the city's old station No. 1. Woodland Horsecar No. 2 (1887) pictured here has been completely restored and is in the Heidrick Agricultural History Center/Hays Antique Truck Museum. (GHM.)

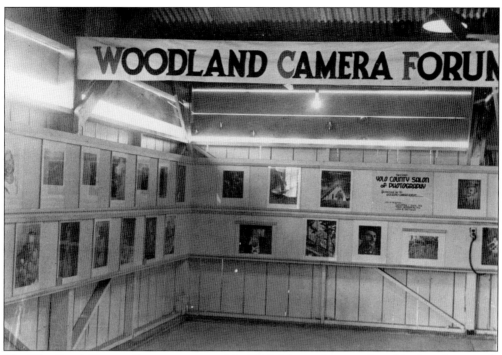

The Woodland Camera Forum was started in 1940. Many of its members liked to photograph Yolo County historical sites. Some also made copies of historical photographs. Exhibits of Camera Forum work contributed to the public's awareness of history in the landscape and created images that have themselves become valuable historical documents. (GHM.)

The one-room Springlake schoolhouse was built on East Gibson Road in 1869. Threatened with destruction, it was purchased through the efforts of the Yolo County Historical Society. Moved about a mile to the county fairgrounds in 1950, it was repaired and given 19th-century furnishings. Volunteers play the part of schoolmarm or schoolmaster during "living history" visits by school groups. During the county fair, the general public can enjoy the recreated classroom. (GHM.)

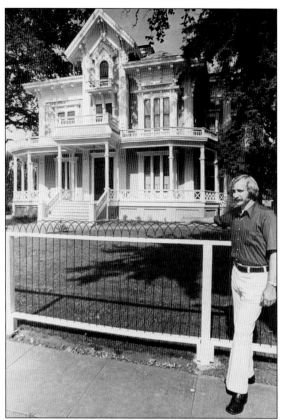

A few early adopters renovated historic Woodland homes in the 1950s and 1960s; the level of this activity accelerated in the 1970s and 1980s, consistent with national trends. Here, Robert McWhirk stands in front of Woodland's grandest surviving Victorian mansion, the 1885 Amos and Harvey Gable house (659 First Street). McWhirk purchased the Stick-style residence in 1971 and spent many years renovating it. The house testifies to the wealth achieved by some Yolo County pioneer agriculturalists. (GHM.)

In many communities, the loss of a prominent historic building often stimulates preservation efforts. Woodland lost the 1893 Farmers and Merchants' Bank to demolition in 1970. It had 3.5 stories plus a parapet, a central location at Main and Second Streets, and an impressive stone facade, making it one of the city's most prominent buildings. Shortly after this loss, the efforts to save the opera house took off. (YCA.)

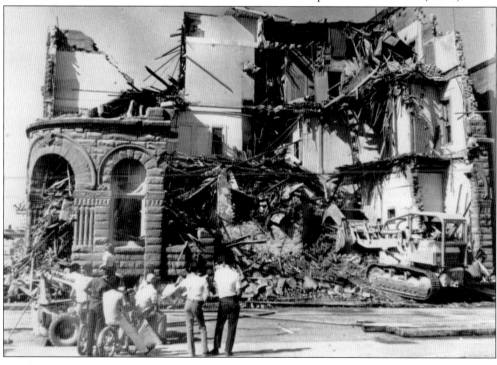

The Woodland Opera House pictured here replaced an earlier one on the same site that opened in 1885 and was destroyed in the big 1892 fire. The new opera house opened in 1896 and provided space for plays, musical performances, lectures, religious and political gatherings, and school and community events until 1913. At that point, the doors were closed in response to a lawsuit filed as a result of an accident on the premises; also, movies were making serious inroads into the audiences for live theater at that time. In 1971, the Yolo County Historical Society purchased the dilapidated building, triggering a decade's effort to raise money via gala affairs and other means for a thorough renovation. Below, president of the Yolo County Historical Society Cleve Baker (left) and University of California dramatic arts faculty member and historic theater expert Gene Chesley (right) inspect the damage caused by years of neglect. (Both, courtesy of WDD; GHM.)

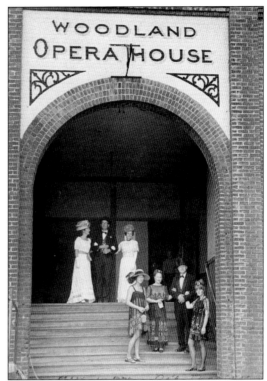

Gene Chesley (left), another UCD dramatic arts faculty member Robert Sarlos, and Mrs. Sarlos attend a function in support of the opera house renovation in the early 1970s. Eventually, the historical society deeded the opera house to the State of California, which provided funds for the building's restoration. It continues to serve Woodland as an important space for cultural and community events, as well as a reminder of the city's vibrant performing arts scene 100 years ago. (Courtesy of WDD; GHM.)

George Weider operated a cigar store on Main Street. This picture of his three sons, (from left to right) Fred, Milan, and Will, and their dog was used on his cigar boxes. Will Weider grew up to be passionately interested in the history of Woodland. In the 1970s, he wrote a series of articles about local history titled "Reminiscing" for the *Woodland Daily Democrat*, reviving a tradition of publications about the region's past. (YCA.)

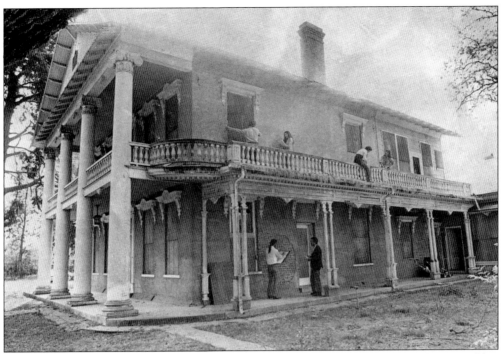

William Byas Gibson bought 320 acres with a small house south of town in 1857. He and his family prospered and remodeled their farmhouse several times, eventually adding the impressive facade of white two-story Ionic columns. Years later, the house became dilapidated; however, some outbuildings and 2.5 acres of grounds survived the encroachment of suburban development. In 1975, Yolo County acquired the Gibson House for use as a museum. Students are shown cleaning up the property that same year. The next year, the community's bicentennial festival was held there. In subsequent years, public and private funds restored the house and furnished it in the period 1870–1920. Regular events include festivals in May and October and school tours for third-graders. The grounds are used frequently for family celebrations. The Gibson House is the only house museum in Yolo County. (Above courtesy of GHM; below courtesy of YCA.)

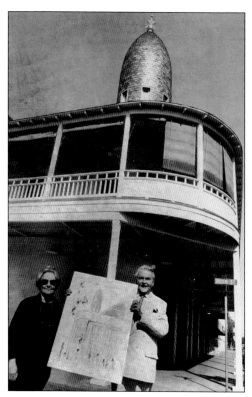

Artist Marianne Ryan (left) stands in front of the Jackson Building holding her drawing of it. In 1985–1986, a group of local investors formed the Jackson Investment Group to restore the 1891 landmark. They made use of federal tax credits designed to encourage rehabilitation. Local architect Gary Wirth adapted the long-vacant attic space for use by Morrison's restaurant. The removal and replacement of the building's iconic tower were dramatic moments in the restoration watched closely by Woodlanders. (Courtesy of WDD; YCA.)

Harriet Stoddard Lee (1859–1951) was a Woodland schoolteacher and Yolo County superintendent of schools. A discussion of women's suffrage with her pupils inspired her to develop activities that honored mothers. She advocated for Mother's Day as a Native Daughter of the Golden West, and the State of California adopted the idea in 1909. The Woodland Downtown Improvement Association put her on this "Women's Appreciation Week" poster in 1984. The Yolo County May is Women's History Month Committee has honored women significant in local history for a quarter century. (YCA.)

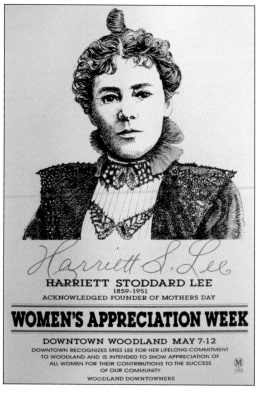

Harriett S. Lee

HARRIETT STODDARD LEE
1859–1951
ACKNOWLEDGED FOUNDER OF MOTHERS DAY

WOMEN'S APPRECIATION WEEK

DOWNTOWN WOODLAND MAY 7-12
DOWNTOWN RECOGNIZES MISS LEE FOR HER LIFELONG COMMITMENT
TO WOODLAND AND IS INTENDED TO SHOW APPRECIATION OF
ALL WOMEN FOR THEIR CONTRIBUTIONS TO THE SUCCESS
OF OUR COMMUNITY.
WOODLAND DOWNTOWNERS

Woodland's Stroll Through History was founded in 1989 and was held annually thereafter for two decades. It offered free guided walking tours of Woodland's older streets and neighborhoods. Paying customers could visit half a dozen private older homes. Exhibits and a vendor fair rounded out the event. Local high school and college students participated in a contest to pick each year's Stroll Through History poster illustration. (Courtesy of BJ Ford; YCHS.)

On August 4, 1979, Bob Craig and Manuel Arteche launched Woodland's first Cruise Night, at which car owners rode the length of Main Street showing off their rides. The event revived a cruising tradition found in many Central Valley towns. In 1988, as a result of complaints generated by the event's increasing size, a more structured two-day format was adopted that also included musical entertainment, chili cook-offs, and a custom car show. (YCA.)

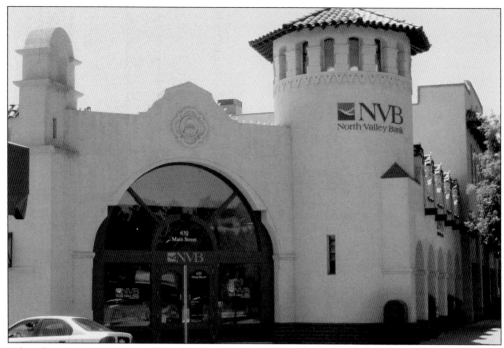

After electric train service to Woodland was terminated in 1940, the Mission Revival depot partially burned and was later demolished. Woodland businessman and community leader Tom Stallard found a set of plans for the depot in the California State Archives and hired architect Duane Thompson to reconstruct it in 1986. It is once again a Main Street landmark. Stallard has renovated a dozen historic downtown structures, including the adjacent Cranston Building. (DJD.)

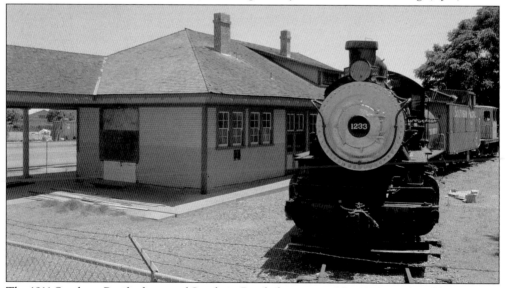

The 1911 Southern Pacific depot and Southern Pacific locomotive No. 1233 are owned by nonprofit Sacramento Valley Historical Railways (SVHR), which is dedicated to the restoration of both depot and engine. Southern Pacific ceased passenger service to Woodland in the 1950s; the company gave the depot and sold a suitable piece of property for it to the SVHR in 1991. The depot has been moved and extensively rehabilitated, involving hundreds of volunteer hours. (DJD.)

Chinese immigrants arrived in Woodland as early as the 1860s. Images of these early Chinese residents or their homes in Dead Cat Alley are scarce. This picture shows a later immigrant family, from left to right, Soo Hoo Shee (Mrs. Low), Harry Low, and Low Keung (Yee Hong Lai) about 1924. Low Keung worked on nearby ranches starting in 1917 and moved with his family into Woodland in 1941. Finding more information about the early Chinese is a challenge for future historians. (YCA.)

Members of Folkorico Latino de Woodland pose on the Yolo County Courthouse steps in this 1991 photograph. The troupe was founded in 1986 by Marina Ramirez, Helena Ochoa, and James Harvey-Keith. It was the first resident arts company in the refurbished Woodland Opera House. The award- and grant-winning group has taught hundreds of children traditional Mexican dances, thereby nourishing Latino culture and historical awareness. (YCA.)

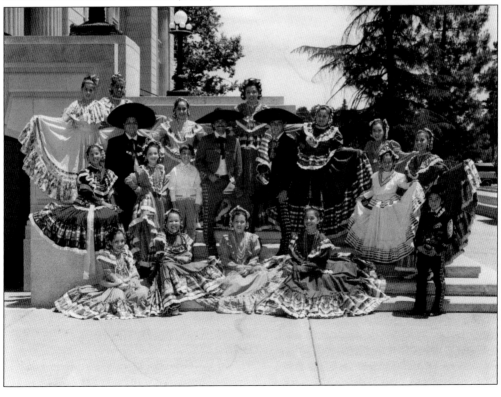

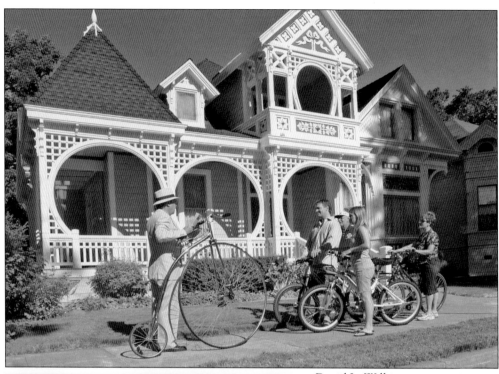

David L. Wilkinson pauses in front of the 1892 Spaulding house, whose owners won a National Trust for Historic Preservation restoration prize, while leading a bicycle tour of historic Woodland. From restoring his own Victorian in 1985, he went on to found, lead, and actively participate in many historic preservation activities in Woodland. His book *Crafting A Valley Jewel* documents the shaping of the city's cultural landscape by architects and builders. (SB.)

Joann Larkey (left) and Shipley Walters coauthored *Yolo County, Land of Changing Patterns* in 1987. Under the aegis of the Yolo County Historical Society, they wrote books on five of the county's towns, including *Woodland, City of Trees* by Walters. These publications furthered interest in local history and drew attention to the value of caring for those resources used in studying it. (YCA.)

In 1930, Clark Field, located on Beamer Street near West Street, was a serious new venue for a hardball-loving town. The 1,400-seat stands and state-of-the-art facilities attracted big names to play at exhibitions and for local teams. In this 1950s photograph, showing Boy Scouts on the field, some deterioration was evident. Now California's oldest continually operating community diamond, a 2010–2011 renovation showed Woodland's love for the venue. (WBS.)

Although the Woodland Cemetery Association was not formally organized until 1869, burials in the vicinity of the Woodland Cemetery date from the 1850s. The cemetery has many splendid old gravestones, such as this one for William Byas Gibson (1831–1906). On Stroll Through History Day, various Woodlanders buried in the cemetery come back from the grave and, dressed appropriately, talk about their experiences—helping to keep history alive. (GHM.)

DISCOVER THOUSANDS OF LOCAL HISTORY BOOKS FEATURING MILLIONS OF VINTAGE IMAGES

Arcadia Publishing, the leading local history publisher in the United States, is committed to making history accessible and meaningful through publishing books that celebrate and preserve the heritage of America's people and places.

Find more books like this at
www.arcadiapublishing.com

Search for your hometown history, your old stomping grounds, and even your favorite sports team.